'Alastair Gordon not only carefully edu
enthusiastically celebrates it, leaving m
author's own thoughtful artwork, this b
are precious truths and cherished storie ⁻, ⁻⁻⁻⁻⁻⁻,
but which also gave me the instinctive d. ⁻⁻ ⁻⁻ ⁻⁻⁻⁻ ⁻⁻ with my peers and students. Why
Art Matters will become one of my treasured books and become a "must read" as I work
with creative students across the UK.' **Lois M. Adams, UCCF Arts Network Coordinator**

'The walls of our world have been shaken to the core by a catastrophic pandemic and, at
the same time, some of our leaders have played fast and loose with established norms,
structures and values. Alistair Gordon in *Why Art Matters* reaffirms a set of values that
are positive, holistic, practical and rooted in the theology of his Christian faith. He
asserts that art is essential because "art is the voice of the human spirit" and can "punch
holes in the darkness" of our grief. Gordon also states that there is a role for the artist
to "clean the windows of the church" so that "the people can see the wonder inside". A
timely appreciation of the importance and significance of the visual arts.' **Philip Archer
OBE, artist and former Principal, Leith School of Art**

'My friend and colleague Ally has written a delightful book and I highly recommend
it. *Why Art Matters* is suffused with wisdom, joy and wonderment of Ally's journey of
faith and creativity through our Creator. This beautiful book, uniquely designed with the
author's own art, captures how the biblical journey towards our thriving must begin with
the statement "art matters because . . ." Ally does so in most memorable and insightful
ways.' **Makoto Fujimura, artist and author of *Art+Faith: A theology of making***

'Living in a visual age requires visual literacy. In this much-needed book, Alastair
Gordon not only explains why visual art matters, particularly for Christians, but offers
hard-to-resist vocabulary lessons. Three cheers!!' **Roberta Green Ahmanson, writer and
philanthropist**

'This is not just a book for lovers of art. This is a book for everyone. It will move you,
inspire you and create in you a greater sense of wonder and love for God and others. *Why
Art Matters* is beautifully crafted, biblically rooted and, at times, painfully vulnerable. It
causes you to stop and be grateful, reflect, rejoice and rest. I wholeheartedly recommend
it.' **Phil Knox, author of *Story Bearer* and Head of Mission to Young Adults,
Evangelical Alliance**

'It seems increasingly common for pastors and theologians to act as cheerleaders for the
arts. Ally Gordon matches the best of these in terms of his clarity, analytical precision
and theological nous, but he has something else: the wisdom and passion of a practising
artist. This book won't just help more Christians to "get art" (although I'm sure it will do
that), it'll help us to make art, and to make more of it in accordance with truth, beauty
and goodness. *Why Art Matters* matters!' **Jonny Mellor, Founding Director, Sputnik:
Faith & Arts**

'Ally is a breath of fresh air! His book and his art call us to reject the lies and see reality as it is: God's reality. So this goes far deeper and wider than merely helping us to get into his art-making. Art can help to restore what it means to be fully human, in all our quirky, created "embodiedness"! Art helps us to stop and appreciate what it means to enjoy God's incredible creation and provision. As Robert Louis Stevenson said and Ally quotes, "art punches holes in the darkness". So by the time you finish this book, you will chime with both halves of his repeated refrain: art matters because people matter.' **Mark Meynell, Director (Europe and Caribbean), Langham Preaching, Langham Partnership**

'Why does art matter? In the midst of a global pandemic, worldwide economic collapse and a fast-approaching ecological doomsday, why does art matter? What contribution do artists make to a world in crisis? Well, as Alastair Gordon argues in his new book, *Why Art Matters*, quite a lot actually. As each chapter unfolds, Gordon builds the case for why art matters today more than ever.

This is just the book we need in these days of global crisis when many of us are filled with self-doubt and pessimism. Every artist, whether Christian or not, should keep this book on their bedside tables, ready to open its pages whenever they question why they continue to make their art. Every pastor should read this book to understand why and how art should be a part of their church communities. Every human being should read this book because, in our own small way, we are all creators made in the image of the "beautiful" God who cares about our world and who loves us. Ultimately, as Gordon writes, art matters because "there is no human in time who does not matter to God".' **James Paul, director, L'Abri Fellowship England, and author of *What on Earth Is Heaven?***

'Read this humane, conversational, incisive book and you will lose count of the ways in which art matters. That is appropriate, because art is overflow; supererogation. Art affirms an abundance deeper than scarcity, a generosity deeper than equivalence, and a gratuity deeper than utility. This book cleans a window to allow its readers to glimpse some of those depths.' **Ben Quash, Professor of Christianity and the Arts, King's College London**

'"Why does art matter?" is a perennial question. In this marvellous and beautiful book, painter Alastair Gordon answers the question, not with a justification, but instead with a multifaceted celebration. Like the many genres of art and the myriad ways they enrich us, Gordon lets bloom a thousand and one answers to the question. And every one is an invitation – "Come and see!" – to a richer world and a better way to be human.' **James K. A. Smith, Calvin University; Editor-in-Chief, *Image* journal, and author of *You Are What You Love* and *On the Road with Saint Augustine***

WHY ART MATTERS

A call for
Christians to create

ALASTAIR GORDON

To Anna – thank you for your love and wisdom

INTER-VARSITY PRESS
36 Causton Street, London SW1P 4ST, England
Email: ivp@ivpbooks.com
Website: www.ivpbooks.com

First published 2021

British Library Cataloguing-in-Publication Data
A catalogue record for this book is available from the British Library.

ISBN: 978–1–78974–236–7
eBook ISBN: 978–1–78974–237–4

Print and production managed by Jellyfish Solutions

Produced on paper from sustainable forests

CONTENTS

ABOUT THE AUTHOR

Alastair Gordon is an award-winning artist and founding director of Morphē Arts, a Christian charity that mentors emerging artists. His art can be seen in galleries and at art fairs around the world and his writing has been published in various art journals and magazines. He lectures at art schools across the UK and is a regular speaker at Christian festivals and conferences such as World Alive, Keswick and Soul Survivor.

INTRODUCTION

This book is about why art matters: an apologetic for art. To give you a hint, I'm going to argue that art matters because people matter and art is the voice of the human spirit. Art speaks for those who cannot be heard and their voice matters because they bear God's image. While we're at it, I'll give you more. Art matters because it points to the presence of God, the ultimate maker and Creator. Art matters because it reminds us of who we are, where we have come from and how the journey ends. Art matters because it abides with us through the storm; it lights a candle when night falls; it salves the soul and quickens the mind. Art matters because it asks important questions, puts grief into words and finds colour for joy and songs for lament. Art matters because it embodies ideas, causing nations to rise and dictators to fall. Art matters because beauty matters, and true beauty is the glory of God. Art matters because you matter and you are made in the image of God.

This is a book for artists, but artists come in various forms. Some paint, sculpt, draw and make films. Others take photographs, write, design, dance, set up small businesses, plant churches and write reviews. Some do this in a professional capacity while others make art in their spare time. All will find this book helpful. If you are an entrepreneur, church leader, teacher or tutor, you will also find relevant ideas in this book. Indeed, this is a book for all who are interested in creative culture or influenced by it. If you go to art galleries, visit the theatre or cinema, read books and magazines, watch TV or wear clothes, you are interacting on some level with the creative arts. Therefore, this is a book for you.

I am an artist and I am a Christian. I write from within these two worlds. To me, they coexist like the warp and the weft,

Art does not reproduce the visible;
rather, it makes visible

Paul Klee

intertwined like that great adventure of life together: a tapestry of art, faith, family, hope, grief and joy; of Holy Communion, yellow ochre and smoky bacon crisps. At times pulling against one another, tugging and fraying, yet at other times aligning like a perfect union in unexpected ways or the tension of opposites. In this book I explore the creative arts through the lens of Christian faith. Some might consider faith to be a naïve, irrelevant or outdated way of thinking, but I encourage you to read on. I hope my conclusions will resonate with you even if we don't share the same starting point. As an artist I cut my teeth in the UK art scene, training at the Glasgow School of Art, Wimbledon School of Art and Leith School of Art, where I now teach. I live and work in London, and I exhibit at various galleries and art fairs both in the UK and further afield. I write from within that art world and will share a few stories of its curiosities along the way. Yet this book is not a memoir or a 'how to' guide. There are other places for that.

Instead, I offer reflections on why art matters from someone who makes it, lives it and loves it and hopes that you will too. At times it may become philosophical, argumentative, even theological, and I hope that, overall, the warps will meet the wefts. Alongside the text you will find images of my paintings. If you are new to my work you might be forgiven for thinking you are looking at strips of masking tape and postcards on paper, but look more closely and you will see that they are paintings carefully constructed to give the illusion of real objects. Indeed, those who

know me best will know of my enthusiasm for *trompe l'œil* and illusionistic painting. The text and the images work together and you might find one informing the other in unexpected ways.

There is a time for everything under the sun and this book was written at a time of seismic global change, being woven together before and during the COVID virus lockdown. An event of such magnitude is bound to affect the tone of its contents and I refer directly to the pandemic in at least two chapters, most specifically chapter 8. Yet this is a book about why art matters at all times and on all occasions, in times of feast and of famine, in sickness and in health.

My thanks go to the Morphē Arts artists, who have listened to these ideas through various lectures, seminars and groups. I thank Cully, Eleanor, Sarah, Lois and Alex for your friendship and adventures over many years. I am especially grateful to Cully, my partner in crime. To Jessica Lacey who planted the seed and Miriam Ettrick who first read and commented on chapters, thank you for sowing that seed and I hope you enjoy the fruit.

I also thank Anna. Whenever I finished a chapter, I would read it to her just before bed. It's here that I found out what worked and what didn't. Thank you for letting me share some of our story, and I know it wasn't easy. I also thank Richard Augustus, who designed the book, Mark Read, our Art Director, and my eagle-eyed editor, Caleb Woodbridge, who offered great suggestions and tweaks for the text. You are all wonderful people and you are all artists. We dance together in the court of the King and clean windows in the new creation . . . but that is to give too much away already.

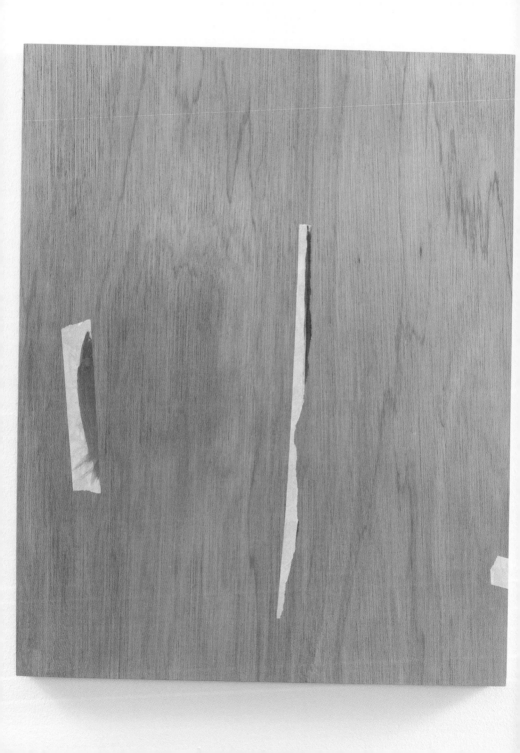

EYES FOR ART

Art matters because people matter and people are made in God's image

Vibac IV
2015
oil on wood

I was at a party when a friend asked a surprising question. We had been talking about the state of the world and suddenly she asked, 'People are losing their jobs, losing their homes and losing their countries. With so much evil in the world right now, why does art matter?'

My response was immediate: art matters because people matter. Art gives a voice to people who can't be heard. Art shapes the way we see the world and one another. Art matters because a beautiful painting or sculpture can transform us in a way nothing else can. It's not just that art can brighten our spirits (which it can). A good work of art can excite or incite, provoke or soothe, inspire or unsettle.

In a world of turmoil, art matters more than ever. Art can bring about positive change, economic resilience, political action, even social revolution. Art reminds us of the things that really matter. Art can lift our eyes to eternity but also show us the importance of the here and now. Art helps us to see what is hidden and opens our eyes to new ways of seeing. As John F. Kennedy said in his final words to the world, 'We must never forget that art is not a form of propaganda; it is a form of truth.'[1]

In a sense we are all artists. Being an artist begins with being able to imagine, and we can all do that. You did it this morning when you woke up and decided what to wear. You did it when you picked up this book and pictured what the contents might be. When we imagine something, we are seeing that which hasn't yet been realized. The task of the artist is then to show us what they have seen. To imagine is to be an artist. And when we imagine we are reflecting the image of our Creator God.

GOD'S EYE FOR ART

The Bible says that when God created the world he said, 'Let there be light' and there was light. I have been painting most of my life and I cannot say 'Let there be art' and have a glorious painting just materialize in front of me. The way that we make things is different from the way that God creates. God creates something from nothing – *ex nihilo*. We make from the things God has already created – *ex materia*.

3

Yet the way we make reflects the character of God. All human beings are made in the image of God. Being made in the image of God is a big idea, with many dimensions to it. For our purposes, a key aspect is that as human beings we are made in the image of the Creator. So to be creative is simply part of what it means to be a human being. This means that creativity is for everyone, not just the professionals. For some it takes the form of painting and drawing; for others it's tending the garden, cooking, making up silly stories with your kids or writing a Bible study for church. Whether you are highly skilled or not, a career artist or a budding hobbyist, all forms of human creativity bear the blueprint of God.

Creativity is more than just a gift from God to enrich our lives and bless the world around us. Creativity is a mandate for all humans. When we are not creative, something is lost in how we relate to God and to one another and how we enjoy the world around us.

When God created the world, he did it with an explosion of colour, shape and texture. He used all kinds of materials and forms. And God said *it is good*. In fact, he said *it is very good*. The earth did not arrive flat-packed from heaven, neither did God make it a concrete jungle. It was beautiful and amazing and surprising and diverse.

God created the trees and said they were 'pleasing to the eye'

4 before he said they were 'good for food'.[2] In the creation story we are told that things looked good before we are told what they actually did. That's why it's important that we make things to look good and not just to serve a purpose. The aesthetic dimension of creation was of the utmost importance to our Creator God; art matters because the way things look matters to God.

When I was a boy, I used to sneak into my grandfather's workshop and marvel at all the tools. They seemed to promise a wonder of exciting possibilities. One summer we made a toy boat together. He showed me how to manipulate the grain, carefully chiselling away the wood to reveal the form beneath. It was such a thrill, and all the more so as my grandfather had lost a finger to that trusty old chisel. He used to joke that ever since that fateful slip and slice, he could only count to nine. As we worked together in his workshop, I could sense his pleasure in my making beside him. When my boat was complete he finished it with varnish and placed it below the mirror in the hall for all to see. I'm sure it wasn't the finest carving he had seen. Neither was I his greatest student. But he delighted in what I had made simply because he loved me and we had made it together.

As those made in the image of God, we reflect God's creative character. I felt this as I chiselled away at my wooden boat, every movement a copy of my grandfather's example. Although I was very young I sensed the joy in my grandfather as he taught me how to carve. We didn't talk much. We just enjoyed the work and the simple pleasure of making something together.

When God created, he said it was good. When we make things

well it brings pleasure to God. My grandfather didn't need me 5
to join him in the carving, yet he delighted in teaching me. In
the same way, God doesn't need our creativity, yet he delights to
see us make. This is simply part of what it means to be a human
being. We don't need to justify it by writing Bible verses in the
bottom right-hand corner or by making plays that are facsimiles
of the Gospels. Whether you write, sing, plant, cook, doodle,
draw, garden, strum, bake, scribble, wiggle, prance or dance, all
these things reflect the creative character of God and are part of
what it means to be made in his image.

AN EYE FOR BEAUTY

Writer and comedian A. L. Kennedy said, 'The things we see every
day tell us whether we matter: whether we are loved; have power.'[3]
Indeed, the things we make and surround ourselves with speak
volumes about who we are and how much we value human life.
We see this in our own homes. Regardless of whether we live in a
palace or a poky flat, we like to surround ourselves with things we
perceive as beautiful. We do this because we think beauty matters.
I've yet to meet anyone who painted their bedroom in colours
that match a car park. Not even the most brutal of Brutalists
would do that. In the same way, imagine if God had created for
Adam and Eve a paradise of utility: a concrete jungle beset with
ugliness and functionalism. What kind of message would that
give to God's people? Rather, God made a lavish garden for his

6 people. The beauty of creation tells us loud and clear that human beings matter to God. Creation is beautiful for its own sake too, but the fact that God prepared a place for humanity within it shows us how much he values us. This also connects with our being made in the image of God. We are all divine image-bearers, so each and every human being has dignity and value, above and beyond any 'usefulness' or economic productivity we may or may not have. The beauty of creation reminds us that we all have beauty and worth in God's eyes.

For centuries, the church has been known for its beautiful buildings; we built our churches to reflect the beauty of God and the wonder of his creation. Imagine if Christians today were to reclaim that same joy in beautiful design in all areas of life, but not least in the buildings where we meet. Imagine if Christians were known again for making things well. What would that say to our world? How would it demonstrate the beauty of God to a culture in need of the gospel? How much would it validate the fact that people matter?

Through the pages of this book, I want to offer an apologetic for art. I'd like to share a little of my own experience as an artist of why Christianity, to me, is the best defence for the importance of art. Yet this isn't just a book for artists. It's a book for all human beings, because all humans are made in the image of the creative God and all people are affected by the power of art. We'll talk about how God created things and why the matter of creation matters to those who live in it. We'll think about what art really

is, what it can be and how it shapes our world. We'll consider why beauty matters and how the ugly things of this world can point to the truth of reality. We'll take a look at some art together and think about creative culture, and by the end of it all my greatest hope is that you'll either be reaching for the pencils or marching through the streets. Yet I want to do all this through the lens of the greatest work of art I have ever encountered: the Bible.

OPEN YOUR EYES

Think about how many pictures you have seen in the last twenty-four hours. Think about how many images you have looked at, in newspaper articles, TV programmes, movies, adverts, images you have seen on social media. Combine that with how many images you have made in the last day. Think of how many photos you have taken on your phone, doodled on a pad or pasted into a document. Now compare that with how many Bible verses you have read today. The chances are you have spent more time today observing or making art than you have spent reading God's Word. And that's because we live in an image-saturated culture. Through social and digital media we encounter more images on a daily basis than at any point in human history. Artist Grayson Perry describes it as 'the daily sewage dump of information',[4] yet through the grime there are moments of wonder to be glimpsed. The psalmist David reminds us that God speaks through all aspects of his creation, including the arts. Psalm 19 begins with the heavens declaring the glory of God and the skies proclaiming the works of his hands. Later, in Romans 1, Paul tells us that God's invisible attributes have been revealed since the beginning of creation through the things he has made. I will argue further on in this book that things such as paintings, movies, websites and plays can be understood as God's continued work of creation

through the skill of human creativity. But for now let us think about how the arts function as a means of communication. Today we have greater access to music, art, games and stories than ever before. Images play a greater role in influencing the way we think about the world than at any point in human history. If you draw close enough you just might hear the voice of God next time you visit an art gallery or turn on the radio.

Now take a moment to look around you. Think about how many of the objects that surround you right now have been made by a human being. Think about that chair you are sitting on, the clothes on your back, the cup at your side and even the book in your hand. Every object in the room you are now sitting in will have begun life as a drawing. The chances are that most of the things that surround you at this very moment will have been touched by the hand of an artist or designer at some point in their conception, design or making.

Great artists shape the way we see and think; they also influence the way we live, move and act in the world. They have the capacity to communicate in a way that others may not. A good artist can help us find the words we cannot think of ourselves. A good artist can help us express our grief or articulate our love for someone. They set a chorus to our mourning and capture the colour of our joy.

Art matters because it matters to God. Art matters because humans have always made art. Art matters because it helps us to empathize with others, celebrate with greater joy or lament with deeper sorrow. Art matters because it penetrates every moment of human existence. It shapes the way we think about God and his world; it changes the way we see one another, the way we live, move and have our being: it affects the way we act and even walk down the street. Art matters because human life matters, and wherever there is human life there will always be great art.

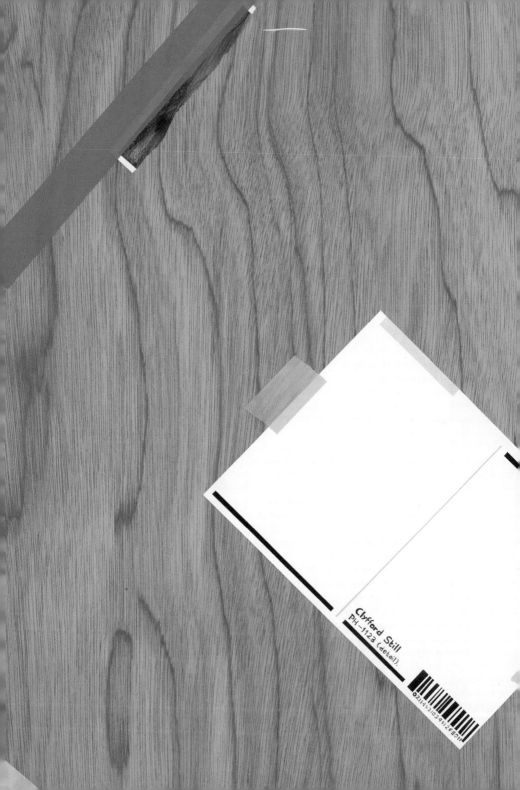

Clyfford Still
PH-112a (detail).

CHAPTER 2

ART
OF THE
MATTER

Art matters because matter matters and shows us that all things are connected in Christ

A Golden Cupidon Peeped Out
2017
oil on wood

There's a kid on our street who likes to paint with mud. He gets the dirt from the garden and adds water, grass and a hint of spit to make a glorious mess of a paint. He likes to slap it around using his hands as a brush and the paving stones for a canvas. It's grubby and earthy and brilliant.

In a sense, artists have always just painted with mud, inasmuch as paint has often just been made from the raw materials of the earth. In its simplest form, paint is particles of pigment that give colour and texture mixed in with a binder, which holds it all together. Traditional pigments such as alizarin red, yellow ochre, burnt sienna and raw umber all derive from organic matter such as plants, soil, bark and beetles. Other pigments come from inorganic material such as rocks, metals and semi-precious stones such as lapis lazuli, which gives us that deep ocean of ultramarine blue. In the past, pigments would have been ground by hand into a fine powder and mashed into a binder such as linseed oil or gum arabic to make oil or watercolour paint.

Some paints come from the most unusual of places. One especially macabre pigment was mummy brown, which was made in part from the putrefied remains of human corpses. Elsewhere, the British landscape painter J. M. W. Turner was famous for his love of Indian yellow, which was made from the urine of cows fed a diet of mango leaves. The urine was combined with clay and then ground down into a fine powder to be mixed with linseed oil before he smeared it across the canvas, often in generous proportions. The glory of the sunset rendered in all the ruddy stuff of clay and urine . . .

Painting is a messy business. Yet from all that mess great things arise. As art historian James Elkins puts it, 'To an artist, a picture is both a sum of ideas and a blurry memory of "pushing paint," breathing fumes, dripping oils and wiping brushes, smearing and diluting and mixing'.[1]

MATTER MATTERS

Art matters because matter matters. God designed our world to be made of things, stuff and matter. Things such as mud, wood, stone, hair, dandruff and cornflakes. He even named the first human after the matter of the mud. The name 'Adam' is similar to *ădāmâ*, the Hebrew for 'earth', and to *ădōm* meaning 'red', suggesting the interconnectedness of human beings with the earthy matter and colour that surround us. Historically, the first red pigments came from the soil. They were earthy, deep and ferrous. Today we might say that Adam was the salt of the earth or as solid as a rock, his name indicating the gravitas of his role, together with Eve, as keeper of the kingdom and having dominion over the mud.

13

Here we see God's grand design for all things connected: that soil and colour and humans and making have meaning together; that colours, stones, grass and people are all mixed together in the palette of God's creation. Just as humans matter to God, so also do colour, form and matter.

TRUTH OF THE MATTER

In Genesis we see how God is interested in the aesthetic dimension of his creation. We have already considered how God made the trees and said they were pleasing to the eye before he declared them good for food. Thus we can see how the way things look and the way things are made are as important to God as the functions they serve. Or, to put it another way, God is interested in both the form and the function of things. The matter they are made from

speaks volumes about their purpose and meaning in the world. Art matters because it brings together matter with meaning: it shows us how form and function work together to reveal God's character. Art matters because the materials of creation reveal the glory of God. As we read in Psalm 19 (NIV),

> *The heavens declare the glory of God;*
> *the skies proclaim the work of his hands.*
> *Day after day they pour forth speech;*
> *night after night they reveal knowledge.*

The creation story encourages us to see that the things God created have the capacity to speak without speaking. They communicate through their form. As we are made in his image, the things we make also have the power to communicate in and of themselves. When God made the skies, it didn't just demonstrate God's enthusiasm for colours. According to the psalmist, the skies also speak of his glory yet without a word being uttered. They communicate though colour, light, form, water, translucency, refraction and mist.

In the same way, the things we make and call art speak volumes about who we are, what we want, what we think of the world and what we think of ourselves. In this way Christianity has always been clear that art can be a way of talking about things that really matter. As modern philosopher Alain de Botton puts it,

Christianity . . . never leaves us in any doubt about what art is *for: it is a medium to remind us about what matters. It exists to guide us to what we should worship and revile if we wish to be sane. It is a mechanism whereby our memories are forcibly jogged about what we should draw away from and be afraid of.*[2]

THROWING MUD IN THE CAVES

It's worth remembering that the idea of art, at least as we know it today, is a relatively modern concept. If we take art to mean some kind of beautiful luxury (to use as a precious decoration) or cultural signifier (to help us discuss things of the world), we must understand that not everyone in the world thinks of art in this way. Before art was shown in public places such as galleries and museums or in private spaces such as homes and personal collections, it was more commonly found in places of public worship such as churches and temples, where it served a very different function.

Way before art appeared in temples and churches, humans made marks in the landscape such as in the caves at Lascaux in France. The paint used by these early humans was sourced from the ground, with pigments most likely being mixed with water and sloshed onto the walls by hand or spat out from the mouth like a rudimentary spray paint. Any speculation about art made around 15,000 to 10,000 BC requires more than a little guesswork,

yet the idea of these paintings as a form of art is well supported by most art historians. The eminent art historian E. H. Gombrich suggests, 'The most likely explanation of these finds is still that they are the oldest relics of that universal belief in the power of picture-making.'[3]

The caves at Lascaux remind us that art has always been a hallmark of human civilization even before people started using words like 'art'. In fact, if we think about art in terms of cultural artefacts – things such as buildings, textiles, instruments for making marks or music, tools for making and cooking utensils – there has never been a human culture where art has not played an important role.

SCRIBBLING IN THE SAND

There are various ways of thinking about art. One is simply the making of marks: a scribbling in the sand. Do you remember the story about Jesus scribbling in the sand? It's good to remember that we don't know exactly what he wrote. I like to think the Gospel writers deliberately left that part out so that we might speculate but never know. What we do know is that Jesus made a drawing on the ground and that modest little scribble managed to silence the Pharisees. Jesus' scribbling in the sand spoke volumes without a word being uttered.

The word 'art' comes from the Latin *ars*, meaning skill, method

or technique. The original Proto-Indo-European root also gives us the word 'arm', so we could equally talk about art in terms of an extension of the human hand. In this way 'a work of art' could apply to a variety of human activities, not just things such as paintings, sculptures or films but anything made by a human being. For example, anything from changing a tyre to cooking a meal or brushing your teeth could be considered a work of art. We might refer to a nasty person as 'a real work of art'. Even an act of crime could be considered artistic if performed with skill. This may sound shocking at first, but art is not required to be good in order to be great. By that, I mean a work of art does not have to be morally wholesome or edifying in order to be considered a great work of art. Neither does it require us to like it or even approve of it. Not all acts of art are 'good' in the sense of what we might think of as moral.

As the origins of art involve both skill and technique, we might ask how closely related art and technology are to one another. Perhaps technology is oriented towards usefulness, and art towards meaning-making. Yet when we make things we are most often including both these aspects, so it becomes more a question of emphasis rather than of seeing art and technology as two separate activities. We see an aspect of art in almost everything that we do; whenever we try to do something well, or even when we don't, we might see a failed element of art. Yet when we suppress the artistic dimension of what we do, it feels somehow less than human.

Papers from My Studio
(Saunders Waterford 300gsm)
2016
acrylic on wood

18 SKETCHY MORALS IN MONTMARTRE

By the mid nineteenth century, an emerging French artist called Edgar Degas was causing a rumpus in polite Parisian society with his controversial new pastel drawings. Degas was known for his dramatic depictions of ballet dancers at rehearsal and behind the scenes at the Paris Opera House, but later, when his artistic gaze turned to the dancers backstage taking a bath, combing their hair and changing their clothes, the polite society of Paris began to ruffle their feathers. When he started to paint the prostitutes of Montmartre it was the final straw, and the Academy banned him from exhibiting in their Salon. Not to be deterred, Degas retorted in his typical taunting style: 'Nude models are alright at the Salon,' he mocked, 'but a woman undressing? Never!'

When we look at Degas' paintings today we might say that our society views them with a different moral attitude. Today at the Hermitage Museum in St Petersburg you can buy a postcard of *La Toilette* (*Woman Combing Her Hair*) in the gift shop for eighty roubles. On last report, it sits in the postcard rack next to the art books for children with a print of the Holy Mother to the left.

A work of art might promote what many would call a morally bankrupt idea yet be rendered with such sensitivity that we cannot help but call it beautiful. There is a tension here in the way we view certain works from the past. Today, we sometimes find ourselves wrestling with art by great historical artists that

demonstrates a sexist or racist attitude or a way of seeing the world that we now understand as problematic. The work of art itself might be great, but that doesn't mean we want to celebrate the opinion of the artist or the prevailing attitude of the time. At the same time, even the clumsiest of painters can deliver a work of art that screams of bad craftsmanship yet somehow shows us something of beauty: an honest evaluation of the world, a thoughtful response to a difficult question or a well-intended idea that somehow became a bad painting.

IN HIM ALL THINGS HOLD TOGETHER

What might we say of all these things? How is the throwing of mud in the caves of Lascaux over 20,000 years ago connected to the doodles of Jesus in the soil of Palestine 2,000 years ago? How does Christ's scribbling in the sand relate to Degas' sketches of prostitutes in Montmartre two millennia later?

When I go to my studio in the morning, I try to begin the day with prayer. I ask God to help me make something that recalls those legacies of art we have come to celebrate as art history. A tradition that began in the caves with the earliest human beings, that was carried across continents in crates of acacia wood, from Africa and Europe, from Asia to the world; lost in the gilded vaults of museums, carved into stone, buried in sand and whispered around campfires from generation to generation. This same legacy that spans the globe and encompasses all people of all times and now finds itself with the burden of potential at the tip of my pencil. I also pray that God might help me just to make the next thing as well as I possibly can, whatever it may be.

As we reflect on the nature of art in the light of God's design, it's helpful to remember that the very materials we work with are

part of his plan. The lead in the pencil and the pigment in the tube are as much of the Lord's engineering as the writing on the wall at Belshazzar's feast and the flicker of inspiration in Mozart's quill. Of course they function differently in creation, but they are no less of the Lord. Each plays a different part in God's design but all fall under the Lordship of Christ. As the Apostle Paul wrote, 'For in him all things were created: things in heaven and on earth, visible and invisible.'[4]

21

Yet when I think of materials such as light, silicon and pigment, they are very different as raw materials from the purpose they serve when wielded by different artists. Not all artists will use them for good. Not all will use them well. Matthew's Gospel reminds us of how God sends rain on both those who do good and the unrighteous. In the same way, we are all afforded by God's common grace a rich plethora of materials from which to make art. The question is, what shall we make with them?

Art matters because the materiality of the world matters. Art matters because it speaks volumes without a word being uttered. Art matters because it has always mattered in the evolution of human history, bringing meaning to the everyday stuff of life and causing human beings to flourish in the mud. From the caves of Lascaux to the dust between Christ's fingers in Jerusalem, even to the brothels of Paris, Christ has made all things and sustains all things. Again, as Paul put it, 'in him all things hold together'.[5]

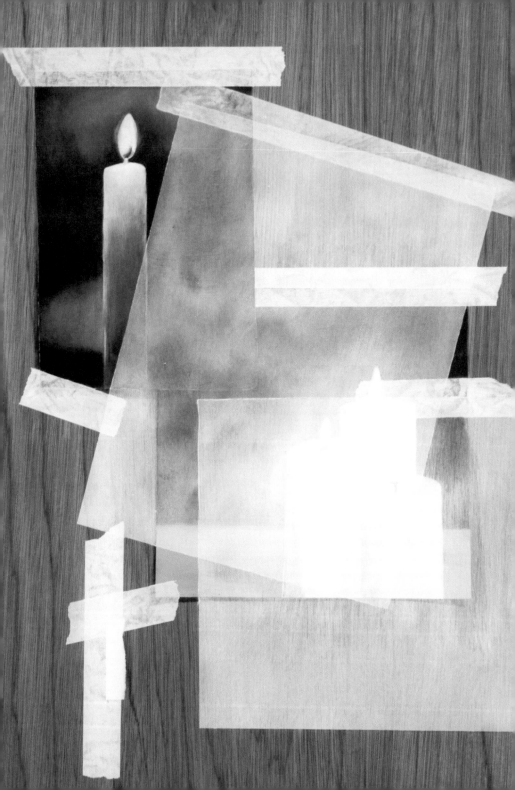

PUNCHING HOLES IN THE DARKNESS

Art matters because it tells the stories of our joy and grief

Memento Mori
2014
oil on wood

> To do the useful thing, to say the courageous
> thing, to contemplate the beautiful thing:
> that is enough for one man's life
>
> T. S. Eliot

24 There is a story often told of the nineteenth-century Scottish author of *Treasure Island*, Robert Louis Stevenson. When he was a boy, his family lived on a hillside overlooking a small town. Robert was intrigued by the work of the old lamplighters who went about with a ladder and a torch, lighting the gas street lamps for the night. One evening, as he stood watching with fascination, his parents asked him, 'Robert, what in the world are you looking at out there?' With great excitement he answered, 'Look at that man. He's punching holes in the darkness!'

A few years ago, my wife and I experienced one of the hardest events of our life together. I'll never forget that moment when the doctor leaned forward, taking Anna's hand and explaining to us that our unborn child would not make it into the world. It was an ectopic pregnancy, where the fetus grows outside the womb and nothing can be done to save it. If you have experienced such a thing, my friend, my heart is with you. We still remember the long evenings of tears and days spent in a haze. We didn't know it at the time, but this was to be the first of several miscarriages and failed pregnancies, each one becoming harder. Another prayer said by the river. Another tree planted in the garden. Another layer of hard skin grown around the heart.

Like many Christian couples, we turned to God for help. At least we tried. If I'm to be honest, we found it difficult to pray. How could God allow this to happen? What was the sense? Where was the good? C. S. Lewis described it well when he wrote, 'No one ever told me that grief felt so like fear. I am not afraid,

but the sensation is like being afraid. The same fluttering in the stomach, the same restlessness, the yawning.'[1]

It is risky at best to share such a story, but I don't offer it as a bid for sympathy. Anna and I have been blessed by good friends and caring family who have walked with us along this difficult path. Yet I want to describe how the Lord offered an olive branch to us in the midst of our despair. It came from the most unexpected of places: it came through the arts. To be specific, a poem. My wife had been seeing a counsellor, who suggested she write a letter to God about how she felt. The letter took the form of a poem. As Anna searched for the words, finding just the right phrase to express what she felt, the salve was applied and the healing began. There was something about describing her feelings in a poem that was especially powerful. Something about finding words that confined the chaos, about seeing rhythm in the boundless discord or simply naming the truth: that painful space where we can sit in the rawness of it all. Neither of us are poets by trade, but that didn't matter. That simple act of poetry was enough to clear a path back to God. It became a focus for our grief and something tangible to remember our daughter by. I don't know why God took our daughter, but I am thankful for these words he left behind. Of course, you never really come back from grief; I imagine we'll carry the loss for the rest of our lives. But the ointment of poetry has been a gift of grace from God to us. The pain is raw, but the ointment spreads deep.

A few weeks later Anna read her poem to a few close friends. They wept with her, one friend admitting she had never realized what it was really like for Anna and saying she just thought of a miscarriage as a medical process and not really the loss of a child. Yet Anna's words in the poem helped her friends to empathize with greater understanding. Art does that. A simple poem can be a catalyst for change. We learned first-hand how the arts can

25

help us find the words when all else is lacking. We dared to look for beauty in the brokenness. Even now, I weep as I write these words and the Lord brings comfort. We no longer feel the anger, but I'll admit to the occasional tear. Yet, through it all, God gives us art and it helps.

Art abides through the darkness. It keeps watch through the storm, holding a vigil in times of need and giving us the words to express our sorrow. In this way, it reminds us of the very character of God, who is not distant but walks tenderly with his people through the darkest night of the soul. Art breaks through the darkness when all else fails. It holds a candle when night falls. Like the lamplighters of Stevenson's childhood, art punches holes in the darkness.

In the previous chapter, I discussed how God champions creativity from the first moments of creation. Indeed, the creation story tells us loud and clear that God is deeply invested in the aesthetic dimension of his world. Yet we only need to read a few chapters into Genesis to see how creativity is corrupted as the whole creation becomes tainted by the fall. Adam and Eve, made for relationship with God and to rule creatively under God, choose to go their own way, disobeying God by eating from the tree of the knowledge of good and evil. This brings sin into the world: a broken relationship with God and all the brokenness that brings to the world. That which once bore fruit becomes barren. The once-fertile soil still yields a harvest, but Adam must labour hard for the fruit. Even the gift of childbirth, the very essence of

new life, was subjected to sin's curse, and what should bring joy 27
so often brings tears and pain. Yet even through the dark lens of
the fall, we see God's light shine. With the promise of redemption
ringing in our ears, a song of hope can be heard with the news of
a saviour: Christ the Redeemer, who makes ugly things beautiful.

We might find a good analogy for Christ's redemptive beauty in
the work of Tolkien. In *The Silmarillion*, he tells the epic creation
myth of Middle-earth. The creator is Ilúvatar, an all-powerful
deity who teaches the Ainur, immortal spiritual beings like angels
or demi-gods, to sing and make music and participate in his song
of creation. It's a rather wonderful picture of art and music as a
catalyst for physical creation. But the most powerful of the Ainur,
Melkor, attempts to disrupt the music of the Ainur by making his
own theme, ugly and discordant, introducing disharmony into
creation. His action might be read as an image of the fall and
of sin.

Yet what happens next is surprising. We might expect Ilúvatar
to cancel out Melkor's disruptive music, to press rewind and start
again. Yet he allows the discordant melody to play out and into
creation. Even more, he interweaves the discordant melody with
the music of creation to allow a tension between harmony and
corruption. Ilúvatar thereby creates a new theme more sorrowful
yet also more beautiful than before. Whereas at first we think
Melkor has ruined creation for everyone, we later see that Ilúvatar
uses his disobedience to bring order from chaos, and deeper
beauty into the story of the world.

I don't believe Tolkien intended the song of Melkor to be an exact analogy of the problem of evil. But it serves as a powerful image of how God allows the corruption of good things, whilst also bringing beauty from the brokenness, good out of evil. We might sense this in a poem that shines light into our darker moments, a song that laments with great sorrow or a beautiful painting that reminds us in hope that death is not the end.

TELL ME A STORY

A work of art behaves differently from other forms of communication. Art appeals to both our reason and our imagination. Art tells a story, and sometimes this has more power than making a statement of fact. As writer Joe Lazauskas puts it, 'Good stories surprise us. They make us think and feel. They stick in our minds and help us remember ideas and concepts in a way that a PowerPoint crammed with bar graphs never can.'[2]

When you tell a story, you spark the imagination. This is how humans have communicated since the beginning of time: even before we learned to read and write, we told stories. Stories are central to the way humans think and communicate. We engage with others through stories and we are drawn to stories often because we see ourselves reflected in them. Stories help us relate to one another. We empathize with the characters and, as a result, they help us to understand how other people think.

I came late to reading. When I was a boy, a combination of undiagnosed dyslexia and a preference for drawing led to evenings lost in sketchbooks rather than the written word. I was all the more impoverished for it, but when I got to art school I more than made up for it. I picked up a copy of the Narnia stories and read them all in a week. Narnia led me to the Shire, from Middle-earth to Earthsea, and then up to the stars with *Ringworld*, Iain M. Banks' 'The Culture' novels, H. G. Wells and beyond. I was rarely found without some pulp fiction rolled up in my back pocket. The stories started to find their way into my painting and for a long time I imagined myself becoming a backdrop painter for sci-fi movies (a small part of me still holds that dream).

I didn't realize it at the time, but these stories helped prepare me for events in my future. It's not likely that I'll be taken off-world or whisked back in time, but Frodo, Aslan and Bora Horza Gobuchul have become teachers and friends. With hindsight, I can see how Horza's down-to-earth heroism in *Consider Phlebas* made him an unlikely role model. Neither did I realize how the tears I shed over the death of the Pevensie children in *The Last Battle* would help prepare me for death in my own family years later. As broadcaster Aleks Krotoski puts it, 'Stories are memory aids, instruction manuals and moral compasses'.[3] They are also trial runs for our emotions and a prep school for hard knocks.

As Christians, we have a wonderful story to tell. A story of grace and beginnings, of rebellion and darkness, of light in the world and a hope for the future. Yet we also tell stories of everyday life,

of rain falling on concrete and weeds in the grass, of the cracking of knuckles and why dogs howl. All these stories are part of God's creation and we are free to tell each one.

I am reminded of how much Jesus liked to tell a story. How many times did he say the kingdom of God is like a pearl, like a net, like a field or like a gate? How many times did he start by saying *there once was a man . . .* or . . . *a farmer went out to sow his seed . . .* or . . . *there was a man who had two sons . . .* ? He once told the story of a man who sold everything to buy a field, of the fisherman who longed for a catch, of the people who travelled along the path and the ones who went to work in the morning. These were everyday stories of everyday people that Jesus' listeners could relate to, and he told them in a way that captured their imagination, at times baffling his hearers to the point of confusion. When his disciples came to ask him what they meant, he said *those who have ears to hear, let them hear.* On occasions like these we might speculate on whether his followers really did understand the point of his message, but Jesus knew this and crafted his stories so those who needed to would come back and ask for more.

A good story gets under your skin. It snares like a barb and niggles, giggles, demanding a second listening. It doesn't have to be clear. It doesn't even have to make sense, but the best kind of stories make you come back again and again. These were the stories Jesus told and these are the stories we too can tell.

PROPHETS, POETS AND AMBASSADORS

Although I didn't read much myself as a boy, I used to love it when my dad read to me. I especially liked the stories of Judges, Samuel and Kings in the Bible. To me they were wild tales of warrior kings and gypsy prophets, of little boys who defeated giants and prophetess assassins who drove tent pegs through the skull of their victims. As we read through Scripture, it's no coincidence that the lion's share of the text comes to us as stories. Many are surprisingly horrific, romantic or macabre. These stories were engraved on my imagination. They got mixed in there with Enid Blyton, Stephen King, *Star Trek* and *Doctor Who*. Songs from church intermingled with lyrics by The Beatles, Joni Mitchell and Blur. They mingled with one another in the bank of my imagination, forming ideas that have come to shape the way I think now. I'm sure I have as many references to popular culture rattling round in my head as I have memorized verses of Scripture.

We are an accumulation of the stories we read and the stories we tell, at least to some extent. As artists of faith we tell the stories of creation: how we were created, how we live now, where we belong and where we are going. There is no biblical restriction on the stories we tell. Some will tell the story of Jesus' life, why he died and rose again. Others will tell stories with colour and pigment, of matter and shapes and the way we see the world. Still

others will tell the stories of the fall: how we are broken, corrupt and in need of redemption. All this in an attempt to be translators and guardians, poets and ambassadors to those who are hostile to God and to those who love him.

PUNCHING HOLES IN THE DARKNESS

Art matters because it helps us understand ourselves and other human beings. Art brings healing and solace. It helps us to remember and lament. As American artist Betty Spackman writes, 'We make art to remind us of the invisible and to heal our forgetfulness.'[4]

In this way we remember that art isn't just a means to jog our memory about what we should or shouldn't do. Neither is it merely a means of representing the world around us. Art can do all these things, yet it also shows the invisible. That death is not the end. That God is near. That God is not always who we want him to be. That God is not who we *imagined* him to be. Art helps us to flourish, ask questions, make a statement, tell a joke or change someone's mind, but it also applies a salve to the soul. Like the lamplighters of Stevenson's childhood, art punches holes in the darkness.

CHAPTER 4

VAN GOGH'S BIBLE

Art matters because the Bible is glistening with art and creativity

Oh Boy, Do We Have the Vacation for You
2018
oil and acrylic on canvas

> I don't believe it to be what most Christians claim but
> I do think we should all read the Bible. It is quite
> arguably the greatest work of art in human history
> Melvyn Bragg

36 One of my favourite paintings is the lesser-known *Still Life with Bible* by van Gogh. Painted in 1885, shortly after his father's death, it depicts a Bible belonging to his father and representing his work as a Protestant minister. In some ways it's a very simple painting, with the open Bible portrayed in yellow and ochre hues, resting on a table and flanked by two candlesticks and a book. In a letter to his brother Theo, Vincent described this painting as 'a still life of an open, hence an off-white Bible, bound in leather, against a black background with a yellow-brown foreground, with an additional note of lemon yellow'. Look again and you can see a deeper meaning in these modest objects. The notebook is in fact van Gogh's well-thumbed copy of *La Joie de vivre* by Émile Zola, which was considered a kind of 'Bible' for modern life. The books symbolize the different world views of van Gogh and his father.

A lesser-known fact about van Gogh is that he trained to become a missionary. Raised in the Dutch Reformed Church and perhaps taking a lead from his father, Vincent worked for several years as a minister to the mining community of Borinage in Belgium. On the evidence of his letters and early paintings, he clearly knew his Bible well and often quoted Scripture to his brother.

We have looked at why art matters because it is made by those created in God's image. We have considered its importance in bringing together the matter of creation with those who have dominion over it. In the last chapter I described how art helped

my wife and me through a personal time of struggle. Here, I'd like to discuss why art matters as seen through the lens of the Bible. From Genesis to Revelation, God's Word is crammed with those who made music, art, design and dance. Think of Adam, the great gardener, Bezalel, the great designer, David, the famous songwriter, and Tubal-cain, the father of all music, to name but a few. Consider the prophetic performances of Ezekiel and Agabus, the singing, the dance, the white garments and the almost theatrical spectacle of the new creation. Scripture is rich in examples of creative expression because God himself is the ultimate Creator.

I wonder what words, images and ideas come to mind when you think of the Bible. Perhaps you picture a leather-bound book like that of van Gogh's painting, or maybe a well-thumbed copy on your bedside table. You might think of a set of scrolls or a cluster of books. The Bible, after all, is not just one but a collection of books, like a library or a favourite album. Others may think of a sword, a light or a guide for the path. I wonder how many will think of the Bible as a work of art?

THE BIBLE AS ART

The Bible presents itself as the living Word of God yet we must also think of it as a magnificent work of art, unparalleled in history because it is both breathed out by God and crafted by human hands. As we read it today, the Bible is sixty books that span centuries of culture and art, masterfully written, epic in its scope and beautiful in its rendering.

In Paul's second letter to Timothy, we read that all Scripture is God-breathed (Greek *theopneustos*). Not many artworks claim divine origin. Imagine feeling the breath of God on your fingertips

as you lifted the pen or etched the parchment. When we read the Bible today we listen to the voice of God, yet there are grace notes left by human hands, each writer distinct in style and voice. The rhetoric of Paul is very different from the poetic rhythm of David, whom Bono describes as 'the greatest blues writer of all time'.[1] In the same way, we learn about Hebrew poetry as we read the Proverbs and the apocalyptic imagery in John's Revelation. David says that Scripture is like honey on his lips and water in a dry and thirsty land. When was the last time you snuggled down under the sheets with a glass of your favourite beverage and let the Word of God drip off your lips like sweet-tasting honey or cool water?

IN THE BEGINNING

We don't need to look far in the Bible to see that God is for art and creativity. In fact, we only need to read five words into Genesis to see how creativity is at the heart of God's character. *In the beginning God created*. Being creative is the very first thing God chooses to say about himself in his eternal Word, so it stands to reason that he enjoys it when his people are creative too.

Shortly afterwards, God said *let us make mankind in our own image*. Being creative is simply part of what it means to be human, and no further justification is needed. As already stated, we don't need to embellish our paintings with Bible verses or write plays

based on the parables to make something that reflects God's 39
glory. Simply to make something well is to reflect the character of
God. The Hebrew word for *create* is *bārā'*. It occurs five times in
the creation account and only ever with God as the one doing the
creating. When human beings create, the Bible uses other words,
such as *to make, to worship, to work* and *to bring forth*. If we were
being particular about it, I suppose we shouldn't say we work in
the Creative Arts. Only God is the Creator. In a way, we might
do better to say we are in the Making Arts or the Worship Arts –
simply the workers or the bringers-forth.

When we read about how God created the universe there is a
sense of rhythm, order and intuition, with God making sky and
seas on the second day and then returning to them on day five
to enhance them with birds and fish. The same could be said of
the night and day he makes on day one, as he returns on day
four to make the sun and moon to enrich his earlier creation.
When I make a painting I tend to begin, like many artists, with
the broad-brush strokes and underlying colour. When this dries
I come back a few days later and enhance the early layers with
more colour, texture and detail. In a way the process of painting
is similar to that of God's creation.

God takes a break as he creates. Not just on day seven but at
regular points throughout the creation process. We hear a rhythm
in creation every evening and morning. Here is a blueprint for all
who create to pace themselves, allowing time for rest between
works.

God is also a good critic. At the end of each working session he stepped back and evaluated his work . . . *and it was good.* On the last day *it was very good.* At first, this may sound as if God is being arrogant, yet critique of himself is more a statement of character than of ego. His creation *was* good. Indeed, it was *very* good. When you or I write a poem or a song or cook a meal, the chances are there will be both good and bad in it, yet God's example should liberate us to encourage the good where we see it as well as to nurture the capacity to identify what needs to be improved.

MADE IN HIS IMAGE

We read in Genesis how God put the first humans in the garden to work it and take care of it. It's important to see how creativity and stewardship go hand in glove at the beginning of creation. For those of us who create today, this is a lesson in how the creative arts can function to sustain the planet rather than diminish it.

Adam is tasked with naming the animals. I would imagine this was a formidable task and rather a long day for him! Yet in naming the animals Adam was sharing in the creative process that God himself had established from the beginning of creation. What an honour it was for Adam to partner with God in the naming of creatures, and we've been doing it ever since. Whenever we make a painting or write a song, the final act of creating is to give it a

title. We even do it with our children. The names we give our kids speak volumes about who we are and of our hopes for our children. Names matter. I never met a parent who named their child 'No-one' or 'Whoever'. We take time over names because they matter, because we see it as a privilege and it reminds us that our children are special to us. In the same way, the naming of God's creation was a great honour for Adam, as the first human to get creative in God's image.

From here, there's no stopping Adam. God makes him a wife, sculpted from his rib – a moment of God making something *ex materia*. On first sight of his lover, Adam writes a poem:

This is now bone of my bones
and flesh of my flesh;
She shall be called 'woman',
for she was taken out of man.[2]

The structure of this poem is similar to that of a haiku in its simplicity of form and economy of language. In the Hebrew it works even better, with the word for *woman* coming from the word *man* to underline the material connection between Adam and Eve. This poem is arguably the first example of human art in the Bible and, from here, creativity explodes.

As the Genesis account expands, we read about Tubal-cain, the father of all who play music. We learn about the beginnings of human culture with the making of tools, tents and agriculture. In the fourth chapter of Genesis there's a rather awkward poetry recital where the villain, Lamech, waxes lyrical about the men he has slaughtered and the women he has conquered. The subject is evil but the poetry is beautiful, showing the complexity of art after the fall.

Not all acts of creativity are pleasing to the Lord. The Bible warns against idolatry just as it affirms the good in art. One well-known idol appears in Exodus in the form of the golden calf. It was most likely fashioned by Aaron the priest rather than by Bezalel, a skilled artist. It was made from the finest materials yet knocked together quickly and without skill. This sculpture caused offence to God. If we understand idols to be those elements that steal worship away from the true and living God, this was certainly the case with the golden calf. Yet it probably wasn't a great work of art either.

I have already mentioned Bezalel, the first professional artist of the Bible. In Exodus he is tasked with setting up a small design school with his friend and creative collaborator Oholiab. Together, they start a workshop and employ apprentices who help them to render the artefacts for the tabernacle. They use the very best of materials, not just wood and wool but gold, bronze and

fine gems. Bezalel is the first human in the Bible to be filled with 43
the Spirit of God for a specific task. Rather than to a great king
or a mighty warrior, it is reassuring for all Christians in the arts
to remember that the first indwelling of God's Spirit was given to
a designer. Bezalel was filled with the knowledge of design, with
the skill and ability to make all manner of crafts. He was also
tasked with passing on his knowledge to the next generation.

ART REDEEMED THROUGH THE CROSS

As Paul wrote to the church in Colossae that God is pleased to
reconcile to himself all things by making peace through Christ's
blood, shed on the cross,[3] we must assume God has a plan for
the arts within his redemption story. Yet how are things such as
movies, paintings and plays redeemed by the work of Christ?
Indeed, how does God work through the creative arts to reveal
his plan to unite all things under Christ?

 Part of the answer can be found in Paul's earlier words, 'in him
all things hold together'. Just as the universe was created by and
through God, so all things are bound together in him, including
things such as sculpture, poems and photographs. In some ways,
Jesus is like the glue of the universe, and not even the corruptive
power of sin can unbind him from that which belongs to him.
At the cross, Jesus restores all things back to God. Like a potter
who carefully restores a broken jar, Jesus makes beauty from the

lost fragments of creation and then makes it better than ever. The root of the brokenness of the world is humanity's broken relationship with God. Out of that fractured relationship come all the injustice and ugliness and division we experience. As the sin of humanity was atoned for, so its effect on the world was finally undone. From here, God makes ugly things beautiful and everything is made new. But these are things we will come back to further downstream.

Nowhere in the Bible do the arts play a greater role than in the creativity of the new creation. We see signs of the good things to come when Agabus performs a kind of art installation for Paul in the book of Acts. Agabus takes Paul's belt and with it binds his own wrists and feet, a prophetic sign of the incarceration Paul would experience in Jerusalem. Isaiah writes about the new creation as a fruitful vineyard that yields its crop for generations unending, with the fruits of their labour bringing wine for ever. He writes about houses and cities where God's people will be the architects and engineers of their own homes. The new creation, like the first creation, does not arrive as if flat-packed from IKEA®. Neither is it zapped into being by the waving of a divine wand. Instead, we read about human making and building, planting and growing, seeding and harvesting. The arts play an important role in the new heavens and new earth, with examples of art as diverse as the nations represented. We read about God's people making music, planting vineyards, wearing beautiful clothes and building houses.[4]

Art matters because the Bible is gleaming with creativity and the 45
arts. From Genesis to Revelation, God's Word is art in itself and is
full of examples of artists who made art for God's glory. We also see
how the arts were subject to the fall. Today, just as in the past, art
has the dual capacity to reveal the things of God and demonstrate
the sinfulness of human beings. We make both art for the King and
idols for the world. Art matters because it matters to God.

CHAPTER 5

MAKE GOOD

Art matters because it brings forth the good works of God

Sacrament - Hidden, Revealed, Concealed
2014
oil on wood

We are God's handiwork, created in
Christ Jesus to do good works, which God
prepared in advance for us to do

48 In this chapter we'll discuss the role of the artist: how we raise a
chorus in the courtroom of the King yet also repair sewers in the
underbelly of the earth. Art matters because artists matter, and
our function in the world is one of imaginative hope, bringing
new ways of seeing and caring for the creation. We are also
humble labourers, administrators and repairers.

Much ink has been spilled over the role of the artist through
the years. In the past, artists have been viewed as craftspeople
and workers, prophets and gurus, shamans and mystics, rebels
and avant-gardists, teachers and instructors, and, more recently,
as celebrities. As Russian playwright Anton Chekhov is often
cited as saying, 'The role of the artist is to ask questions.' He later
reflected, 'It is not however our role to answer them.' Others take
a more cynical view. Indeed, Andy Warhol is often cited as saying,
'An artist is someone who produces things that people don't need
to have.'[1]

Ted Turnau is a professor of cultural and religious studies in
Prague, and he describes artists as zookeepers to the imagination,
our role being to guard and attend that menagerie of beasts we
like to think of as creative culture.[2]

In a similar way, contemporary artist Makoto Fujimura
petitions artists to be in the vanguard of culture care. Taking our
cue from the creation mandate in Genesis, we are called to be
stewards of creation, like Adam in the garden: to cultivate the
soil of the arts as the Lord brings the rain, so that the result may
be fruit.[3]

When I think of others who have described the role of the artist, the theologian Trevor Hart comes to mind. His description of the artist is that of an apprentice in the workshop of God, the great master craftsman.[4] As we sculpt and paint, our creative actions echo those of our Father in heaven, who made all things and said, 'It is good.' Yet it is more than that. As he is the master of the workshop, all the tools and materials belong to God. His name is above the door and printed on the invoice. We may make and mend in our own unique way, but it was God who first gave us the skills and gifted us the tools. As we are reminded in Psalm 24, verse 1, 'The earth is the Lord's, and everything in it.'

BRINGING FORTH

Art changes and the role of the artist changes with it. Our task today is not the same as it was centuries ago, yet there are some things that never change. As a Christian I am bound to the teachings of the Bible that inform me that God is the same yesterday, today and for ever, and that there is nothing new under the sun. God may not change but creative culture does, and our role as artists changes within it.

Previously, I mentioned the Hebrew word *bārā'*, which describes the creativity of God. The Bible has other words to denote the creativity of human beings that help us understand the role of the artist in God's kingdom. When referring to Bezalel and his team of designers who made the artefacts for the tabernacle, the Hebrew word *'āśâ* means *to make*. This is different from *to create*. God creates something from nothing but humans make from that which already exists. The Exodus account describes Bezalel's artistry as being of the highest standard of excellence. Indeed, we could say he was 'making good'. Bezalel set up something of an

50 art school with his friend Oholiab, and they served as tutors to their apprentices in woodwork, embroidery and metalwork.

In another story from the Old Testament, Joshua, the great warrior, crafted knives out of flint and the same word is used: *to make*.[5] We see it again when Ehud crafts a sword for himself,[6] as Gideon casts the gold to fashion an ephod,[7] when Samson and David prepare an elaborate meal,[8] at the construction of Solomon's Temple[9] and on numerous other occasions when human beings are tasked with making things well. In all these situations, the task of the artist was to 'make good'.

Yet the Bible also talks about human creativity in terms of labour or work, using the Hebrew *'ăbōdâ*, which also means *service*.[10] The task of the artist here isn't just to make good but also to graft hard and to serve.

THE STATUE IN THE STONE

One of my favourite descriptions of the artist's task is the Hebrew word *yăṣā'* (or *ekpherō* in Greek), meaning *to bring forth*. We see it again and again throughout Scripture, like a repeated lyric in the chorus of the Bible. We first encounter it in the creation itself: whenever nature bursts with fruit, it is said to *bring forth*. We see it as the plants are cultivated and multiply.[11] We hear it again when Ruth gleans the remains of the barley.[12] After Adam made love to his wife, Eve, she became pregnant with Cain and said, 'With

the help of the Lord I have *brought forth* a man.'[13] Whenever the creation is replenished, restored or recreated from the materials of the creation itself, the chorus rings out: *bring forth*!

The artist Michelangelo is often cited as saying, 'The sculpture is already complete within the marble block . . . I just have to chisel away the superfluous material.' By this he meant that his statue of David was already there in the stone. His job was simply to bring it forth.

If the role of the artist is to bring forth new works of God's creation, perhaps our task is similar to that of Michelangelo: to find what God has made and reveal it to the world. It's a bit like children at Christmas unwrapping the presents under the tree.

In another sense, Paul wrote to the church in Colossae, ' . . . all things have been created through him and for him,'[14] speaking of Christ the maker and sustainer of all things. In Paul's argument we glimpse one of the ways in which God continues to create after the events of Genesis. He reminds us that all things are made through Christ. The gifts under the tree have already been wrapped by Jesus; ours is the task of bringing them out and unwrapping them. If all things have been created through him, the presents under the tree include more than things created in the first six days of creation. So we're not just talking about mountains, rivers and animals but things made by human agency, such as laptops, mountain bikes, paintings, operas, comic books, kitchen towels, primary schools and pistachio ice cream. All things have been created through him and for him.

To me, this is one of the greatest mysteries of creation: how God continues to create all things and how he might use us to do so. It demonstrates the extent of his generosity to and partnership with those made in his image. Indeed, Paul also wrote, '[W]e are God's handiwork, created in Christ Jesus to do good works, which God prepared in advance for us to do.'[15] If we take the analogy in a

new direction, we are not only the children who unwrap the gifts at Christmas; we are also counted among the presents. For we are created in Christ Jesus to do good works. Here then is our task: to open the presents of God's creativity to show them to the world yet also to serve as a gift of God's grace. Ours is the good work prepared in advance by Christ. Ours is the art that makes good. Yet they are not ours by right, but Christ's work through us and his gift of grace through the arts to the world.

53

PAINTING WITH DAD

As we think about God's ongoing creativity and our agency within it, an analogy might be found in the way children make art. Our children are often the greatest teachers and my daughter, Lilli, certainly knows how to show me a thing or two about life. Lilli is seven, an age of wonder, empathy, joy and more than a little feistiness (a characteristic of which I am quietly proud).

Last week we were painting together in my studio. It was a simple exercise, allowing acrylic to partially dry before going back into it with water. If you get it right, the paint curdles and reveals the layers below. Tones build up in layers of glazed colour and the impact is rather exciting (for both adult and child). When Lilli's friends came round later for a playdate she rushed them to the studio, beaming with pride, to show off the paintings she had made. When one friend asked her how she did it, she explained the process and even showed her how to make one herself. The whole thing was rather delightful, a snapshot of innocent wonder, and it reminded me of something about how we create in the image of God.

When Lilli and I made our little acrylic paintings it was I, as her dad, who gave her the colours, brushes, canvas and water.

I gave her the instructions and showed her how to do it. Yet by the time her friends had arrived she was already taking credit for the work.

'How did you do it?' asked her pal.

'First I did this . . . ,' replied Lilli, ' . . . then I did that . . . and then I did this . . . '

As I listened to Lilli relate the process, I didn't feel the need to correct her. It never crossed my mind to say, 'Actually it was *me*!' In the same way, we are artists who work in the studio of Jesus, the great carpenter from Nazareth. The materials belong to him, all the pigments and the binder; every process is part of his design, generously gifted to us to enjoy and further his creation. He doesn't demand the credit yet is delighted when we thank him. As I took delight in Lilli's enjoyment of painting and even celebrated with her as she celebrated with her friends, so our Father in heaven enjoys our creative character simply because he loves it when we make things.

CREATION'S SONG

When we think about the role of the artist, we might consider these words in the Bible: *make, worship, work, serve, labour* and *bring forth*. This list is not exhaustive. Indeed, it is only the start, and we have yet to discuss the artist as prophet, comforter, teacher and much more.

As we reflect on how bringing forth relates to the artist's task today, we might ground it in that mantra from God as old as time itself: 'Be fruitful and increase in number; fill the earth and subdue it'.[16] This mandate in creation has a beautiful ring to it in the original Hebrew text. Spelled phonetically, the instruction is *peru, urebu, umilu, uredu*: be fruitful, multiply, replenish and have dominion. The words have a rhythm and resonance, as if sung over and throughout the earth, a harmonious undertone in creation's song.

The final instruction, 'have dominion', is dovetailed with the mandate to subdue the creation. An instruction to bless and steward and not to oppress. The word *umilu* can be translated as 'replenish', as it appears in the King James Bible, or 'fill' and 'complete', as seen in more recent translations. Translated as such, this rhythmic pulse resounds, 'enrich, expand, fill and complete'. *Peru, urebu, umilu, uredu*: here then is the task of all humanity, in which the arts must play their part: to enrich, expand, complete and steward the creation. At times this includes performing on a national platform, receiving accolades and awards for new and innovative art. On other occasions we will need to roll up our sleeves and get our hands down in the muck. As stewards of creation we are entrusted with the maintenance of the planet. As with all good systems, things go wrong. For many, our calling as artists will be more like that of repairers, nurses or farmers. Some will mend, some will care and others will plant the seed that produces fruit in creative culture. Others still will be tasked

with taking out the rubbish or clearing the sewer. Not all tasks for the artist bring fame, accolades and pleasantry. We make art in the presence of the King, but we also tend the soil of the arts.

Each of these studies from the Bible offers a hint of the task and character of the artist. Where God is Creator, we are the makers. When God creates, we bring forth. Ours is to care, labour, work, worship, serve, enrich, expand and complete.

Art matters because artists matter, and we play an important role in the administration of God's kingdom. Art matters because we are apprentices in the workshop of the Creator, children who play in their Father's studio, workers in the tradition of the great carpenter from Nazareth who manipulated wood, crafted words and worked with the power of the Spirit to redeem all things. We are artists who serve in the kingdom of God, bringing forth the new works of creation, made good through the work of Christ, cleaning toilets in the kingdom and fixing the light bulbs . . . And he is making everything new.

CLEANING WINDOWS IN THE NEW CREATION

Art matters because it embodies our hope to come

Sacrament (lateral composition)
2017
Oil on wood

> Imagination, ambition and hope are some of
> the foods that feed the artist during darker times.
> They can be mere escapism or they can give us
> a new sense of direction and intention
> Justin Welby, Archbishop of Canterbury

60 If you follow the winding streets of Aix-en-Provence uphill from the railway station, you might stumble across the gated entrance to a studio that once belonged to the Post-Impressionist painter Paul Cézanne. To this day, both his studio and his garden remain preserved as a museum. Tall windows illuminate the treasures within. You might see his easel and plan chest, with his paints preserved like holy relics or archaeological remains. A curiously long window cut into one side of the studio was designed by Cézanne himself so that paintings could be passed in and out with ease. Cézanne's palette rests by his easel, placed as if the artist were about to begin a new work. The ornaments seem strangely familiar and then you realize you have seen them in his paintings. We see apples, books, a skull, playing cards and painted bottles, all reminders of his early still-life work.

On the day I visited, Provence had just experienced one of its hottest summers on record: the kind of dry heat that gathers the dust and sticks it in your throat. Approaching through Cézanne's garden, I noticed an old man wiping the dust from the studio windows. It seemed a thankless task, as the dirt would blow up again almost as soon as it was wiped away. Yet he persevered. I asked him why he kept at it and his answer was humbling: 'Les gens ont besoin de voir la merveille a l'intérieur,' he said. *The people need to see the wonder inside.*

SEE THE WONDER

His words struck me then and have stuck with me to this day. Like the dry Provençal dust, they refuse to be wiped away. In many ways, that old man is a perfect analogy for our role as artists. Jesus described the new creation as a house with many rooms. Some might assume he was talking about a house in heaven like some kind of celestial palace beyond the stars, somewhere we go when we die. But 'the Father's house' more likely refers to the Temple, the earthly dwelling place of God where heaven met earth: an echo of the new creation. Even now, he is preparing a room for us. I wonder what that will be like? I imagine that, like the studio of Paul Cézanne, the rooms contain objects of wonder, treasures from the past that remind us of the artistry of God and the great things he has done. Artefacts that tantalize us with the prospect of the life yet to come. How strange and familiar they will seem to us. Cézanne collected letters from friends, and I wonder if we might also see cherished items stored up by our Father. Mementos from our journey with him: our days written in his book, our tears collected in bottles.

61

In the previous chapter we looked at various roles for the artist in the world and in God's kingdom. Art matters because artists play a vital part in the care of creation, bringing forth the works of God that he has prepared in advance for us to do. Here, I would like to expand these ideas and argue that art matters because it offers a glimpse of the new creation. We make art to care for our culture, punch holes in the darkness and show how all things are connected and redeemed under the Lordship of Christ. Yet we also make art to wipe away dust from the windows of our Father's house. We are the window cleaners of the new creation.

At times we may find it a thankless task. Like the dust of Provence, the flotsam of the earth will return almost as soon as it

62 is cleared away, yet there are moments when we catch a glimpse of the new creation. If the wind abates, the dirt will fall away and we can reveal the wonder.

IMAGINATIVE HOPE

In 1944, during the Normandy campaign, a British soldier called Basil Spence was asked by a friend what he was going to do after the war. He had been an architect in peacetime and his answer was, 'I'm going to build a cathedral.' Five years later, fired with imagination, hope and ambition, Spence won the competition to design Coventry's new cathedral. It would become one of the great post-war symbols of peace and reconciliation in the UK and was finally completed in 1962.

I have visited the cathedral many times. It rises from the ruins of the former cathedral, kept as a memorial to darker days and former glory. The building is flooded with light and dominated by Graham Sutherland's epic tapestry, a vision of the resurrected Christ surrounded by the four evangelists. Outside, Jacob Epstein's sculpture *St Michael's Victory over the Devil* stands to remind us that death is overcome. Indeed, the whole experience of the building reminds us that death is not the end and hope abides in the resurrected Christ.

When hope fires our imagination, it can give us the courage to pursue grand ambitions. Hope is different from optimism.

Whereas optimism is based on an ideal, hope is grounded in things we know to be true. Indeed, the writer to the Hebrews describes it as an anchor that goes before us into the presence of God. For the Christian, hope is based on the resurrection of Christ, an event which reminds us that death is not the end and greater things are still to come. Christian faith is often misunderstood as blind hope or optimism, yet the evidence for Jesus' resurrection compels us to investigate further. Hebrews 11 reminds us that faith is being sure of what we hope for and certain of what we do not see. But hope is not a matter of gazing towards the future with blinkers on. Rather, hope in Christ is founded on the reality of Christ's resurrection: evidenced in the past, experienced in the present through the Spirit and anticipated with great expectation for the future. In the resurrection of Jesus Christ, we have a hope that is more grounded than stone or architecture. It dares us to dream, build, make, grasp and draw because it is the gift of God and hope for the new creation. Art matters because it gives us a glimpse of the good things in store. Like the ambition of Spence's architecture, our art can point to the hope we have in Jesus. Our art can be a visualization of our hope for the new creation.

DANDELIONS BY THE TOMB

There are various ways in which the new creation is represented in the history of art. One is seen in fourteenth-century German and Flemish art, where the humble dandelion came to symbolize Christ's death, resurrection and new life. Beneath the tomb, there was colour in the weeds, a sign of hope yet to come. In *The Three Marys at the Tomb*, attributed to Hubert van Eyck, we see an angel guarding the tomb after Christ has risen. Look closely and you'll see a shimmer of gold in the long grass where the Roman

guards sleep in neglect of their duty. This is a painting for Easter, but it is also one of ascension. As Christ has risen, even the weeds have light and colour.

The Bible offers multiple images of the new creation. One is found in Paul's first letter to the Corinthians. He reminds us that love never fails, that we are known completely by our Father and that one day we will see him face to face. Paul says we see a reflection of the new creation as if staring into a mirror. In time we shall know God fully, just as we are fully known to and by him, but for now we see only dimly, as in a mirror. If our task is to wipe the dust from the windows of our Father's house, perhaps another way of seeing it is to polish the mirrors in the new creation. As we paint, sculpt, write and dance, we are buffing those mirrors to reveal God more clearly.

65

THE ROAD TO EMMAUS

Another image of the new creation is found on the road to Emmaus. Luke tells us that the road was short, only seven miles, and the two disciples who left Jerusalem that first Easter morning had probably walked it many times. They knew how long the journey would take them physically, but they had no idea how far they had to travel spiritually before the day was over. Joined by a stranger, they had no idea that God, in the form of the resurrected Christ, was walking alongside them. Imagine their despair as they walked that road. The man to whom all their hopes were pinned had been brutally murdered and his followers scattered.

Suddenly their eyes were opened and they could see Jesus in his new-creation body. But the revelation didn't come in a blinding flash. It rarely does. It came in the simple act of breaking bread. God was revealed in the everyday.

When Caravaggio imagined this story, he placed it around a kitchen table. The disciples are sharing a meal, eating round the table and perhaps telling stories from the journey. He painted the scene at least twice, and on each occasion it takes place in an equally unremarkable setting. My favourite version hangs in the National Gallery in London. The domestic scene is mundane but the painting is full of energy and surprise. In the centre, Jesus radiates light as a calm presence, one arm raised in a welcoming gesture. The major drama is seen through the eyes of the disciples, who are jumping from their seats, arms outstretched, and even the food seems poised to catapult from the table. Caravaggio captures the joy and confusion so well. To me, it is the perfect image of the new creation breaking through into everyday life.

As followers of that same carpenter from Nazareth, we too may find ourselves on the road to Emmaus. The resurrected Christ walks with us even when we don't recognize his presence. At times, we are so needy that he may even use a slice of bread to break through to us, or perhaps a building, painting or poem.

There is more than one road to Emmaus. If you were to go to the Holy Land today and try to find it, you might lose hope. There are at least five contested locations for the ancient village of Emmaus and four equally contested roads to take you there. Of those four roads, one is completely overgrown and you have to search in thick brush next to a busy motorway into Jerusalem to find it. One only exists on an ancient map, and that is now thought to be under a paved road. The remains of one more

are mostly contained within a convent and the remnants of yet another are scattered with signs and warning of landmines. (If you take this latter road you might come face to face with the risen Lord Jesus rather sooner than you expected!)

The road to Emmaus is neither easy nor straightforward. As we walk towards the risen Lord Jesus we might have hoped for smoother roads and better paths, but what we get is some version of the Emmaus road that feels overgrown and unclear. Yet if we think we have to walk it alone, there is hope. This gospel, this resurrection story, assures us that, whether we recognize it or not, the risen Lord will always be our companion on the way.

GLIMPSES OF THE NEW CREATION

The story of Emmaus gives us courage and reminds us that, wherever we are on our artistic journey and however isolated we might feel, we are never alone. We don't have to live as those whose hope is in the past but as those who embody a new life of hope with the risen Lord today and for the life yet to come. The new creation cannot help but break through. This is a hope that transcends our fears and our anxieties and that is available to us all and always.

Yet we no longer journey to Emmaus; we are now artists on the road to the New Jerusalem. Art matters because it can offer a glimpse of the new creation. It can fire our hope with great

ambition for the things yet to come and give us courage to live today in the light of eternity. The great gift of the artist is to express this hopeful imagination as we render in paint, stone, wood and film. There is a home for us that is being prepared by the risen Lord Jesus. It has many rooms and is closer than we think. Art matters because it wipes away the dirt so that we might peer through the windows and see the wonder inside. The goodness of God leaks through from the new creation. Our task is to polish the mirrors and clean the windows.

WHY BEAUTY MATTERS

Art matters because beauty matters and true beauty shows the redemption of God

Nautical Map
2013
oil on wood

If thou of fortune be bereft,
and in thy store there be but left
two loaves, sell one, and with the dole,
buy hyacinths to feed thy soul

John Greenleaf Whittier

72 Art matters because beauty matters. We have heard it said that beauty is in the eye of the beholder. This is to say, beauty is subject to personal tastes, preferences and experiences. In the past, *beauty* has been associated with the unquenchable virtues of goodness and truth. In a classical sense, beauty involved a harmonious assembly of shapes and forms, yet in the Dionysian tradition it was more about lavish abandonment and the glorious negation of rules. Today, some might say that beauty is a social construct or a human invention to describe the finer things in life or serve as a conduit of power.

In such a medley of meaning it seems impossible to characterize beauty, but perhaps we don't have to. Here I would like to discuss a few possibilities, without everything being pinned down, for exploring why beauty matters.[1] While we may struggle to define it, most of us agree that beauty is a *good* thing. We might disagree on what it looks like, but we all want it and like to surround ourselves with things we perceive as beautiful. As William Morris famously put it, 'Have nothing in your house that you do not know to be useful, or believe to be beautiful.' Even now, as I write that sentence in my studio, I wonder which of the two I am!

BEAUTY, GOODNESS AND TRUTH

The Bible has several words for beauty. One of them is *nāwâ*, which means *lovely*. The prophet Isaiah says, 'How *lovely* on the

mountains are the feet of him who brings good news.'² In the Song of Solomon, the teacher says to his lover, 'Your cheeks are *lovely* with ornaments, your neck with chains of gold.'³ Here, beauty is related to a desirable person or object: a beautiful ornament, a lover or even a landscape.

Another term for beauty in the Bible is the Hebrew word *ṭôb*, which means *good* or *true*. It wins the beauty contest of the Bible and we see it 562 times. It crops up in 1 Samuel when we read about the future King Saul, who was very *good and true*. Later, the prophetess Esther was known all over the land for her *goodness and truth*. It features in that verse we read a moment ago from the prophet Isaiah, but this time it takes a rather surprising form: 'How *lovely* on the mountains are the feet of him who brings good news,' but the prophet goes on to say, 'who brings glad tidings of *good* things, who proclaims salvation, who says to Zion, "Your God reigns!"'⁴

When the Bible talks about beauty, it most commonly equates it with goodness. This moves beauty beyond the way things look to a deeper, more resonant understanding of the word. Saul and Esther didn't just *look* good; they *were* good. In the same way, when God said of his creation, 'It is good', the Bible translates it as *ṭôb*, meaning beautiful, good and true.

When we talk about things that are beautiful, we are really talking about things that are good, which may help us to see the difference between a surface appreciation of beauty, which is open to personal taste and preference, and a deeper understanding of beauty, which resonates in eternity. Here, it is possible for something to be both ugly and beautiful. Even ugly things could be part of this harmony in the world. Umberto Eco points this out in his book *On Beauty*, where he writes, 'Beauty . . . also springs from the contrast of opposites, and thus even monsters have a reason and a dignity in the concept of Creation . . . alongside [evil], good shines out all the better.'⁵

In a previous chapter I referred to Tolkien's creation myth in *The Silmarillion*, where we read about Melkor's disruptive song in the otherwise harmonious chorus of creation. The symbiotic relationship between beauty, truth and goodness is also disrupted by the fall. Just as Melkor's corruptive melody brought discord into the creation song of Middle-earth, so sin has broken the harmony between goodness, beauty and truth. Living in a fallen world means that we now experience ugliness and evil as everyday reality. What we know to be true is so often evil and not good. That which is evil in the world is made to look beautiful, and we find ourselves attracted to things that are ultimately to our detriment. In a similar way, we find it easier to think about how we look from day to day than to ask the more probing questions about the goodness of our character.

In Ancient Greece you might have found yourself a victim of physiognomy: that antiquated 'science' which assessed a person's character and personality based on the physical attributes of their face. Put in its crudest form, if you were beautiful you were considered a good person but if you looked ugly you were shunned as evil. A man with large eyes or big nostrils was labelled a brute but a slender nose and long neck showed that you were wise. Such outdated practices might seem ridiculous today, but the study of physiognomy was influential in various forms right up to Victorian Britain. Nineteenth-century criminologist Cesare Lombroso proposed that all criminals are born with certain physical traits such as a large jaw, a sloping forehead, handle-

shaped ears and a hawk-like nose. It seems laughable today to think that a criminal might receive a harsher sentence simply because he or she had a wonky nose. But the ancient practice of physiognomy reveals an evil truth that has penetrated deep into the human heart and endured through the years.

We all, in varying ways, make judgments on a person's character based on how they appear. It might be as simple as the clothes they wear or the cut of their hair. At best it leads to a casual misunderstanding of one another. At worst it cuts to the very heart of divisive attitudes based on a person's race, gender, age, sexuality or disability. All demonstrate the fragmented relationship between beauty, goodness and truth. Part of the reality of life after the fall is that something good can be misrepresented as ugly and something bad can be disguised as beautiful. The human heart, like Tolkien's elves and men, has the capacity for both evil and good.

But the gospel gives us hope for this broken reality. The cross shows how God can take an ugly injustice and turn it to good, even making it beautiful as we see his self-giving love revealed. It is here, at the cross of Christ, that we see our greatest hope for the redemption of human endeavour. At the cross all things are restored back to God, where beauty and truth are reconciled through the goodness of God's love.

MONET'S GARDEN

In the Bible, beauty isn't connected merely with goodness and truth but also with justice. When we read of God's justice on the cross, we sing of our 'beautiful Saviour'. Even more, biblical beauty isn't something to observe from the outside but something we are invited to experience from the inside. Specifically, from inside the presence of God, and this is made possible by the death and resurrection of Christ. As writer Roberta Ahmanson puts it, 'The Bible states that our moments of being in beauty rather than outside it as observers will become our everlasting experience. The abuse of beauty that began in the Garden when Eve yielded to the temptation to disobey God . . . will be over. We will live forever in tangible beauty, inside and out.'[6]

We catch a glimpse of this eternal beauty in the words of Psalm 27 (NIV):

> One thing I ask from the Lord,
> this only do I seek:
> that I may dwell in the house of the Lord
> all the days of my life,
> to gaze on the beauty of the Lord
> and to seek him in his temple.

The experience of beauty from within may at first seem an alien thought, yet it's something we might catch a glimpse of, and

more often than we think. I have often been curious about the relationship between painting and gardening. Indeed, some of the best-known artists of the twentieth century were keen gardeners: Gustave Caillebotte, Pierre Bonnard, Emil Nolde and Max Liebermann, to name but a few. There's something about the experience of a wonderful garden that helps us to know beauty in a tangible and immersive way.

If you follow the stream of tourists down the River Seine to Giverny, you might stumble across the home of Post-Impressionist painter Claude Monet. His garden was rather remarkable and great fun can be had looking out for his favourite spots to paint. Both the lily pond and the blue bridge have been lovingly recreated to appear exactly as you see them in the paintings.

What struck me most about my own visit to his home was how every room in the house had been carefully designed to make the most of the light, every one with a view of the garden and decorated in just the right colour. The kitchen, painted in lemon yellow, is crammed full of Japanese wood prints and etchings. The whole effect, to me, is utterly beautiful.

There are some homes that speak volumes of the person who owns them. When the psalmist describes the house of the Lord, we see clearly the beauty of its owner, with the architecture, design and decor revealing the splendour of the King. It is here, says the psalmist, that he wants to dwell. As in a beautiful home, we want simply to sit and enjoy it. Only here, the host is with us. We may even gaze on the beauty of his presence. This is where

we were born to live. It is here, in the presence of the beauty of the Lord, that we look out and see the world for what it really is.

All of this is why beauty matters. We often hear it said that all truth is God's truth. By the same token, we might also say that all beauty is God's beauty, in so much that everything that points towards the redemptive love of God through Christ and reveals a glimpse of God's eternal presence will show us something of divine beauty.

BEAUTY THROUGH THE YEARS

One reason we find it difficult to talk about beauty is its changing characterization through the years. Much ink has been spilled on the philosophy of beauty through the years and it is not my intention to offer a historical overview here, but there are markers in history that might help us see why the idea of beauty has become so complicated.

It's hard to find a specific time when humans began talking about beauty, and Greek philosophers Plato and Aristotle seem as good a point as any. Yet their formal way of seeing beauty – harmonious relations experienced through nature and evidenced in musical notes, ratios of numbers and the more noble dimensions of architecture – was already there in the legacy of Pythagoras. Somewhere in the fifth or fourth century BC, Pythagoras described all things as being formed in accordance

with harmony. Such harmony of form was seen in the natural world, in the stars and, therefore, among the gods. In these early descriptions of beauty there was a symbiotic relationship between a beautiful form and concepts of the divine. Times have changed and most people today think differently from our ancestors, who regarded beauty as inseparable from its parallel qualities of goodness, justice and truth.

Ben Quash is Professor of Christianity and the Arts at King's College London. He writes,

> One of the great dilemmas of the modern period is our loss of faith in the relationship between the good, the true and the beautiful. Our ancestors in pre-modern times – by which I mean pre-16th century – simply assumed a connection between beauty, goodness and truth. It was something they would have taken for granted, without feeling the need to justify or prove it. But we have since begun to doubt that there is a necessary connection, and we can't imagine anything that would prove such a connection.[7]

This disconnection between beauty, truth, justice and goodness may have begun in the eighteenth and nineteenth centuries, with groups like the Aesthetic Movement and celebrated figures such as Oscar Wilde leading the charge.

Wilde believed strongly that art didn't have to express anything beyond itself. To put it another way, 'Art for art's sake'. While this

mantra is often attributed to Wilde, it doesn't actually appear in his writing, although he notoriously claimed in the preface to his dark novel *The Picture of Dorian Gray*, 'All art is quite useless.' When art becomes immoral, or *a*moral, it no longer bears a responsibility to goodness and truth. Indeed, beauty becomes its own justification. This way of thinking about beauty has had such a penetrating and popular effect on creative culture through the years that it is difficult now to get around it.

In the past, beauty has been regarded in a formal sense. It has also been discussed in terms of its ethical or moral code. Where once beauty was talked about as a quality found in exalted things that could bring you nearer to God, the idea of beauty in moral terms comes under attack as we move from Ancient Greece to the medieval period and on to the Modern.

A third way of thinking about beauty can be found in its relationship to pleasure. This form of beauty is defined in terms of how it feels, and the greater the sensual experience, the greater the beauty. Nietzsche pointed out in the late nineteenth century that the Greeks did not only give us a kind of beauty that depends on patterns, proportion and regular form or a kind of moral code bound up in ideas of truth and goodness, but that they also gave us a very different and intoxicating kind of beauty, which he found in the rhythmic flux of song and dance, movement and flow. This is the kind of beauty he calls 'Dionysian'. It is an experience of beauty that enjoys a fluidity of form, an abandonment of moral

hierarchy and the desire, above all things, for life to feel good or
be fun. It is perhaps here that more recent Dionysian mantras
such as 'Express yourself', 'Go with the flow' or 'Just do it' find
their origin.

THE FEET OF THOSE

How, then, might we experience beauty in our everyday lives in
a way that is meaningful and beyond the superficial? How might
we even attempt to approach such beauty in our art?

The prophet Isaiah found beauty in the feet of those who
brought good news.[8] He must have been on to something,
because Paul later repeated it in his letter to the Romans.[9] If the
feet of the evangelist might serve as an analogy for divine beauty,
perhaps there is hope for those of us who wrestle with pigment,
canvas and brush. While I don't think Isaiah was championing
the physical form of toes, skin and bone, he did see their greater
potential in delivering a message of hope. Perhaps the role of the
artist is like the feet of the evangelist. Feeling the dirt under our
feet and at times weary from the road, we are yet able to carry a
letter of hope and know the weight of the message.

If God calls us into an experience of his divine beauty, if we
might know what it is to sit in the presence of the Lord Almighty
and know we are wholly loved by him, if we might catch glimmers

of that hope in the daily moments of life and offer others an opportunity to share in this beauty, then surely we have been touched by the glory of God. Art matters because it reminds us of the presence of God. Art matters because beauty matters and true beauty is the very essence of God.

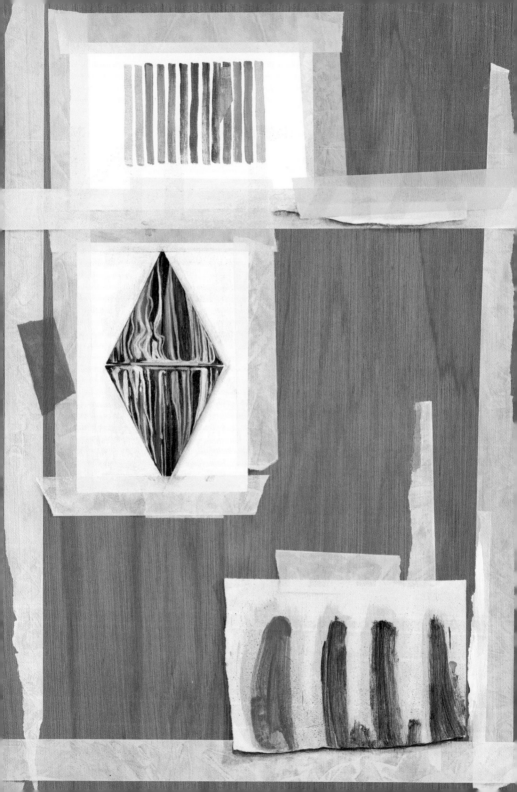

ART IN TIMES OF CRISIS

Art matters because it
abides through the storm

Studio Remains (after Karen David)
2016
acrylic on wood

> In our most dire hours, art keeps us sane,
> lights the dark and ensures we stay human
> Benjamin Law, journalist for *The Guardian*

86 As I write these words, our world is experiencing its greatest crisis for a generation. Indeed, a version of this chapter was first delivered as a lecture to fellow artists in the first month of the coronavirus lockdown. As such, it may read like a rallying cry to the troops in a time of crisis. And that's exactly what it is. By the time you read this the virus may be over. Yet there will always be a moment of panic, a time of crisis or uncertainty, because this is a universal feature of a fallen world. In this regard, I offer my thoughts from when we first went into lockdown, and I hope they will serve to reassure you that art abides through the storm. Art can inspire the weary, show signs of light in the darkness, help those who mourn and, most of all, hold to account the governments and authorities who make decisions on our behalf. Art abides because art is made by human beings and we are made in the image of God – the rescuing King who abides through the storm.

When the COVID pandemic first spread across the world, when entire countries first went into lockdown, when people were sick and dying in terrifying numbers, when unprecedented measures around the globe forced human beings to isolate from other human beings, when governments stumbled in their efforts to contain the virus, many might well have asked why art matters.

Can a painting find the cure for the coronavirus? Can a sculpture allocate medicine to the sick? Can a photograph stop our local supermarket from running out of basic necessities like toilet rolls and pasta? It might be tempting to answer these

questions with a pragmatic 'no'. But it's precisely at moments like these that art matters more than ever.

In the past, artists such as Michelangelo, Rembrandt, Frida Kahlo, Christopher Wren and many others have responded to times of national sickness and mourning with great acts of creative ingenuity. We all respond differently in times of crisis. Some used the enforced self-isolation as the opportunity to create a magnum opus. Others were glad just to get through the next couple of weeks of lockdown without pulling down the curtains. Many find it difficult to create in crisis. Others thrive.

In 2014, Tate Modern put on a major retrospective of works by the early-twentieth-century Russian artist Kazimir Malevich, an artist as influential as he was radical and who has cast a long shadow over the history of modern art. Malevich (1879–1935) lived and worked through one of the most turbulent periods in the twentieth century. Having come of age in Tsarist Russia, he witnessed the First World War and the October Revolution first-hand. He was imprisoned for his controversial abstract works that turned a simple geometric form into a powerful work of political subversion. In the Tate exhibition, it wasn't just the scope of his work that was impressive but the fact that he created so many of his best-known drawings while subject to incarceration in what we can only imagine to be one of the most horrific gulags of its time.

While many of us will find Malevich an inspiration at times of crisis, others will see him as an impossible role model. As one of our very own artists in Morphē said, 'It's not just that I feel bad because I don't feel creative right now – I feel bad because I can hardly get out of bed.'

ALL THAT TIME WE THOUGHT WE'D HAVE

When the government first announced that we were to begin the process of self-isolation I was listening to the Radio 4 programme *Books and Authors* – I should say at the time I was already alone in my studio. The programme was a conversation between two writers, Petina Gappah (author of the recently published *Out of Darkness, Shining Light*) and Henry Porter (who wrote *The Dying Light* and *A Spy's Life*). They were talking about books they were hoping to read while in self-isolation. Henry said he was looking forward to finally getting around to *War and Peace*. Petina said she was dusting down *The Lord of the Rings* again. It's funny now to think back to when we all thought we'd have lots of spare time for reading. Life, for many of us, seemed to enter a strange and parallel virtual universe of Zoom, Skype, FaceTime, WhatsApp, news reports and silly clips of people singing opera to their neighbours across the street. We were lucky if we even managed the opening pages of *The Hobbit*, let alone the entirety of *The Lord of the Rings*.

Many of us felt busier than ever, overwhelmed by our new life online. Yet others felt the opposite. There was too much time now. Some of us lost our job and all sources of income. Life swung abruptly from unbearably busy to painfully quiet. Neither of these grounds are fertile soil for feeding the imagination, let alone productive of the finest crop of your creative career. In

times like this, perhaps we should give ourselves a little break. To allow one another to respond differently. To raise a glass both to those who are making great art throughout all this and *doing* and to those who just . . . just . . . well, *just don't even ask*!

When I first heard that we were ordered to isolate ourselves from one another, I must admit the hermit inside me rejoiced. 'At last!' I thought. A chance to finally lock myself away from the world and get on with all that stuff I'd wanted to do for ages. All that reading to do, all that painting, all that writing. No more late-night tube journeys across London from art events. No more seeing people I didn't really need to see but felt I had to. Shameful, I know, but I wonder if some of you secretly felt the same way?

Then, of course, it dawned on me how much I need the connection with real people in real time. I realize now how much I miss the handshake of a friend, a conversation at a private view and a cup of tea with my parents, who are not young, not in a *safe category* and not nearby.

I am, at heart, an introvert. As with many artists, my idea of a perfect day is to self-isolate in the studio and do nothing but read, drink coffee and paint. Yet even the most introverted among us, when faced with enforced isolation, may feel that pang or that need for social interaction. We need each other. We need to experience one another in a physical sense and not just see one another on a screen or listen to a voice down the phone.

90 **ART IS NOT SOCIALLY DISTANT**

As I've been reflecting on why art matters in turbulent times I've been reminded how art, at its best, isn't just something we look at from a distance or view through a mediated platform like a computer screen or a phone. Great works of art are experienced in a holistic sense. We move around them, reach out to touch them, feel their texture and watch as the light moves round the room; how the sun reflects and refracts off the surface as the day moves on.

And I'm not just talking about visual art. When we go to a movie we don't just look at a screen; we hear the surround sound and sense the reaction of our fellow audience members. We smell the popcorn and feel the sticky patch on the floor where someone spilt their cola. When we go to the theatre it's almost as if we can reach out and touch the actors in front of us. Great works of art aren't just seen, they are experienced. They are not socially distanced – they seep through our skin and invade our inner organs. They spread from person to person. They infect us and become part of us.

Art is not socially distant because God is not socially distant. Just as the Creator exists in community and desires his people to join with him, so humans, made in his image, are designed to live together and experience one another in a holistic sense.

In a world of turmoil, art matters more than ever. Art abides with us through the long haul. Art eases us into the 'new normal'.

Art salves the soul yet can lead us to the brink. It helps us to mourn what is happening to us, to our world and to our loved ones. Art is the poem that finds the words when all other words fail. Art is the painting that knows the colour of our grief. Art is the actor who identifies with us and says, 'Yes – this is happening and it might not be OK.'

ART THAT ENDURED

As we look back through art history, at least in the Western tradition, it's useful to remember how vast swathes of Renaissance and Baroque art were delivered to us against the backdrop of regular outbreaks of plague and disease. From the mid fourteenth to the late seventeenth century, much of Europe was rife with sickness, pestilence and death. It was awful and it lasted a very long time. In E. H. Gombrich's classic book on art history, *The Story of Art*, that period in art history takes up all of chapters 11–22 and there are only twenty-eight chapters! This means that many of the Old Masters, as we call them now, were living in the shadow of sickness. Michelangelo, Rembrandt, Salvator Rosa, Caravaggio, Titian, the Cranachs, Bosch and many more: they would all have lived under the constant threat of epidemic and in fear of the unknown infection lurking in the cities or even in the artist next door. Some great artists died of it. Others tried to fight it with art.

At the end of the First World War, as a new strain of flu spread through the trenches and around the world, it was artists such as Egon Schiele and Edvard Munch who captured the suffering of everyday people. Indeed, if we look closely at Munch's *Self-Portrait with the Spanish Flu*, painted in 1919, the artist represents himself almost as a faceless ghoul, malnourished and restricted

to his bedroom. His unmade bed is painted with greater clarity than the pale features of the sickly artist himself.

We might also think of the Mexican painter Frida Kahlo, who didn't just suffer from polio as a child but was seriously injured in a traffic accident. Many years of her youth were spent in isolation as she was bed-bound in recovery. Frida's mother made a special form of easel so that she could paint from her bed. It was here that Kahlo found her own language of paint. It was here in sickness and isolation that she found her voice as an artist. More recently, the work of artists such as David Wojnarowicz, Keith Haring and Robert Mapplethorpe forced us to talk about AIDS at a time when very few wanted to acknowledge the crisis. These are all artists of the past who have worked through times of illness and national anxiety, and this is to say nothing of those who are working now, even as I write.

ART ABIDES

Not only can art help us to lament and mourn at a time of international sickness and death, it can provide us with a sign of hope in dark times. Art can be a means for social interaction, economic resilience and even political subversion. It was Malevich who showed us the way. At times such as the pandemic, it is all the more important that the arts not only support our national infrastructure but also hold to account the government decisions that will affect us for many years to come. At a time when our authorities have been granted more power than during normal times, we need the arts to remind us of what it means to be human, to have rights and to flourish.

Art matters not just because it helps us empathize with others, celebrate with greater joy and lament with deeper sorrow. Art

93

matters not just because it punches holes in the darkness and brings solace to the soul. Art matters because it penetrates every moment of human existence. It shapes the way we think about this world, it changes the way we see one another, the way we live, move and have our being, in sickness and in health. It will help us to ask questions of the authorities in times of crisis and to chronicle the times.

Art matters to me, not just because it reminds us of an ideology from the past, not just because it serves as a chronicle of how people lived a generation ago – from which we can learn so much. Art matters because it helps us count the time now – as we live through it – it reminds us of who we are in *this* moment. It helps us to be mindful of this moment and acts as an aid to refresh our memory in years to come. Art matters because art abides. Through the storms of history as well as in the calm, there has always been great art because there has always been human life. Art abides through it all. And even in this it reminds us of the very character of God. Art abides because God abides.

CHAPTER 9
STANDING STONES

Art matters because it reminds us of the past, expresses the moment and points to the future

Fifteen Paper Planes
2016
oil on wood

There are moments in painting when unexpected things happen. A watermark expands beyond your control, a pigment works against its nature or serendipitous marks take over. At times it's a happy accident. At other times it's a creative disaster. When things really get going it's like riding a wave where you just have to go with the flow, sensing the energy around you and working with the current. That sense of intense mindfulness or hyperfocus is often referred to as 'creative flow'. It was psychologist Mihaly Csikszentmihalyi who first coined the phrase in 1975 to describe that state of complete absorption, trance-like or even hypnotic, where nothing else matters but the pure rhythm of making.

There are times when I feel that rhythm in the studio. It happened last night as I completed a large still-life painting at two o'clock in the morning. The paint was ebbing and flowing over the surface with an agency that emerged after an entire day of painting, but only now, at the end of things, did the rhythm emerge.

SPEAKING IN TONGUES

To me, painting is like speaking in tongues, that ancient language in which the Spirit of God takes over and new sounds emerge like a groundswell of water and the soil becomes full of life. Within moments the artist will understand what is happening, but the full interpretation doesn't really come till later. In these moments of creative flow, we might sense the Spirit at work. Where God sends the rain and we work the ground. Where structure and play find their communion. Where heaven touches earth on the surface of a canvas and the Spirit dances with the pigment on the end of your brush. When it happens to me it is truly humbling, and both energizing and exhausting.

There are moments in painting that feel enigmatic, like the Spirit hovering above the waters or the wind soughing through the trees. Yet there are also moments when the Spirit rushes in like a sword with great urgency and clarity. As with the prophet Agabus, who took Paul's belt and tied it round his wrists in a form of performance art to warn Paul of the dangers ahead. Or the prophet Ezekiel, who lay on his side for 390 days as a sign to God's people that they must turn and repent. Such works of the Spirit may have been spontaneous but they were hardly obscure: they represented a tangible voice from God that left no doubt in the prophet's mind as to what God was saying.

99

Art matters because the Spirit of God can speak through it. God might use a work of art to reveal something of his character, the brokenness of the world or our need for healing. He might speak through the artist to give specific insight into a political event or national crisis. It might be a word just for you. It might be something we all need to hear. A great work of art can ask a question, probe a statement and get under the skin of what's really going on. In this way art might serve a prophetic function or, at the very least, uncover hidden truths. Art matters because it can make an account of our time, a record of historical events, a monument to those who lived through it and died because of it: a telling, a wake-up call, a standing stone.

ART IS NOT BENIGN

In 2011, a group of artists began to make work in response to the devastating tsunami and nuclear fallout in the Fukushima area of Japan. As the world came to terms with the impact on human life, these artists began to observe and document what was happening on the ground. In time their art would become

critical of a government that attempted to cover up the extent of the disaster, and they got into trouble for speaking out. Such was the pressure on galleries to toe the party line that opportunities dried up for these artists. Like prophets without honour, they had to look elsewhere for their voice to be heard.

I first got to meet some of these artists through Art Action UK, a residency programme set up by artist Kaori Homma. At the time I was running a small gallery in East London and we co-hosted several exhibitions of their work in the initial years. I was particularly struck by the integrity of their voice, by their being honest about the situation as they saw it and not shying away from the difficult issues. They are artists within their time, making work of the moment and speaking truthfully about a situation others hesitate to confront. There is something prophetic in their voice. As contemporary artist Mark Wallinger puts it, 'Artworks should engage, articulate, problematise, open new ways of seeing, place the viewer in jeopardy of their received opinions, move the artists to the limits of what they know or believe, excite, incite, entertain, annoy, get under the skin and when you've done with them, nag at your mind to go take another look.'

Art asks the questions no-one else wants to ask. Art sometimes makes Christians uncomfortable because it asks questions and describes experiences in a very open-ended way. It can question or challenge dogmas and easy answers. But if we are confident that the Bible genuinely describes reality, we shouldn't be scared of probing questions or different viewpoints. Art brings about

social revolution and political subversion. It abides through the revolution and *is* the revolution. Art can change attitudes, shift perceptions and shape the way we think. Art is not passive. It certainly isn't nice. As Kaori Homma herself puts it, 'Art is not benign.'

AN ARTIST IN TIME

Looking back a generation, I am reminded of the American illustrator Norman Rockwell, who, to me, was another artist in his time. Rockwell had an adept way of seeing the moment and chronicling what was happening around him. His was a period of great optimism, energy and the 'American dream'. At times, his paintings showed life in all its fullness, with plenteous Thanksgiving tables and childhood adventures full of great abandon and freedom from care. Yet his was also a time of great diversity and struggle. His painting *The Problem We All Live With* was his first commission for *Look* magazine and chronicled the events of the 1960s schools desegregation crisis in New Orleans. It shows Ruby Bridges, a six-year-old African American girl, being escorted on her way to William Frantz Elementary School by four US deputy marshals. On the wall behind her are racist graffiti and the aftermath of a splattered tomato. Rockwell was both praised and reviled for his take on racial tensions in the Deep South. One man from Texas wrote in to the magazine to

say, 'Just where does Norman Rockwell live? Just where does your editor live? Probably both of these men live in all-white, highly expensive, highly exclusive neighbourhoods. Oh, what hypocrites all of you are!' Yet others would disagree. In the same editorial another reader from Florida stated, 'Rockwell's picture is worth a thousand words ... I am saving this issue for my children with the hope that by the time they become old enough to comprehend its meaning, the subject matter will have become history.'

Rockwell continued with his portrayal of politically charged events as he saw them, stating, 'I just wanted to do something important.' This sense of wanting to do something important is shared by many of us in the arts. For better or worse, we want to speak out. We want to ask the questions. We want to be a voice for those who can't be heard.

Rockwell's paintings have become part of an American visual tradition and influential in the wider visual culture of the arts. They remain divisive even to this day and remind us that art is problematic at its best, but this is not to be avoided.

Art matters because it gets people talking. It can be a chronicle of our times because it speaks for those who lived through them. It can jog our memory in years to come. Whether we agree with it or not, art tells us what people really think, and that, in itself, can lead to healing.

STANDING STONES 103

In the story of Joshua, God commanded the Israelites to take stones from the river and build a lasting monument to remind them of their delivery from racial segregation and slavery in Egypt. The stones were retrieved from the River Jordan and formed into a kind of art installation. The very stones they walked over during their dramatic escape as God parted the waters became the material reminder of their rescue and a lasting memorial to what God had done for them.

They were to make twelve works of art, one to represent each tribe, possibly like standing stones as a memorial for generations to come and to remind them of what God had done. Whether you believe the story in a literal sense or not, it acts as a helpful example of how art can serve another prophetic function in reminding us of events that should never be forgotten. Where the memory fades, art abides. When the facts become clouded in time, art retains the memory of those who lived through it.

SAVING THE WORLD

There are dangers in writing a book on why art matters. It could imply that art is the solution to all the world's problems, which, of course, it isn't. I would never advocate that art will save the world. But I hope my arguments have persuaded some that God

does work through the arts to bring about change. A second danger is to suggest that the role of the Christian artist is to change or convert the creative arts. Those of us who identify with the Christian tradition believe that Christ is the only hope for salvation and he alone can redeem all things. Yet the arts may serve as a conduit of God's grace and he may work through us, as artists, to do the good works prepared in advance for us to do.

In this chapter I have argued that art matters because it offers a prophetic insight into the events of our times. It can uncover the truth of the matter and remind us of what really happened for many years to come. Yet art is not a form of propaganda, neither is it a sermon or an evangelistic tract. When propaganda makes a statement, there is no opportunity to argue against it. When art asks a question, it invites you to respond. In this way, art should open up a conversation rather than close things down.

Art can ask a question. It doesn't need to have the answer. It can engage with the alternative perspective and can encourage critical thought. There will be art made during our time that will help us to remember these days for generations to come. Some of it might come from you. Some of it might even come from me. Yet all art is important because it is made by human beings and we matter deeply to God. We live through the moment and see events from our own unique perspective.

Art matters because it challenges perceived norms. It asks questions of the authorities and speaks for those who wouldn't otherwise be heard. Art matters because we can hear the voice of

God through it. In moments of unexpected revelation, the Spirit moves, leaking over the surface of the canvas and spreading out the pigment. If you listen carefully, you might just hear his voice.

COME AND HAVE BREAKFAST

Art matters because it helps us find rest in Jesus

A Storm Rises
2021
oil and acrylic on wood

A poor life this if, full of care,
We have no time to stand and stare
William Henry Davies, poet

Through the course of this book, I have proposed various reasons for why art matters. We began with the idea that art matters because people matter, and art is the voice of those made in God's image. We looked at why art matters because the Bible is teeming with so much of it. Art matters because the material of the earth matters and things such as pigment, movement, rhythm and tone remind us of how God intended the world to work. We have considered the role of the artist in caring for creation, bringing good, fighting evil, punching holes in the darkness and cleaning windows in the new creation. We have seen why art matters in times in crisis and how beauty can demonstrate the redemption of God. Art reminds us of our past and points to the future. It asks the difficult questions and challenges perceived norms.

In this final chapter, I would like to share a brief word on the importance of rest as part of your creative practice. If you've stuck with me this far I'm pretty sure you agree that art matters. If not, thank you for holding on to the end! I have tried enthusiastically to encourage the making of art, but I hope my words aren't misinterpreted as implying a pressure to work all the time. I have mentored many artists for whom burnout is a very real possibility. It is dangerous to offer advice, especially when unsolicited. As Gildor the elf once said to Frodo in *The Lord of the Rings*, '[A]dvice is a dangerous gift, even from the wise to the wise.' Even so, I hope you don't mind a few words from a seasoned artist about how to dig in for the long haul. My advice might not be what you expect, especially in a final chapter where one usually

finds a rallying cry to the troops. Instead, my advice is this. Here it comes. Are you ready?

Work less. Rest more.

There, I told you it wouldn't be what you'd expect. Here are a few reasons why.

SEASONS OF ART

A career in the arts is more of a marathon than a sprint and it is important to run the race well, with vision and vigour, knowing when to pick up the pace and when to catch your breath. Not all will make art for a living. Indeed, most of us find alternative sources of income to afford time in the studio. This is normal for artists and a familiar strategy for making ends meet. Others will make art as a hobby or pastime. In whichever category you find yourself, the principle is the same. See your rest time as an important part of your creative discipline. Without sufficient rest it is difficult to sustain any kind of meaningful art practice. Indeed, as church pastor and author Mike Breen has said, 'We are designed to work from a place of rest, not rest from work.'[1]

The Teacher of Ecclesiastes reminds us, 'There is a time to weep and a time to dance. A time to plant and a time to uproot.' There are times when the studio will seem overwhelmingly busy, with pending deadlines and gallery interest colluding and colliding in the most inconvenient and exciting ways. At other times it is painfully quiet, with no-one phoning and no prospect of work. It can feel as if the great river of art flows ever onward while we wave from the banks. This is all normal and to be expected. There is indeed a time to plant and a time to uproot.

When I was a boy, my family lived in an agricultural community in the north of Scotland. Our neighbours were farmers and knew

all about the seasons of the land. In winter, the soil must rest so it can recover lost nutrients. On the surface it looks as though nothing is happening, but dig a little deeper and the earth is at work restoring the integrity of the soil. Unless the soil is allowed time to rest it won't bear fruit in the seasons to come. In nature, as in art, the best fruit is born from rest. In the same way, the creative soil of our art practice needs time to replenish itself. This might be a season of research and sketchbook work. It might be an artist's residency or course of study. It might simply be a season to watch movies, read books and visit galleries.

Every season must run its course in order for the artist to be mature and complete. If the crop is sown too early, the harvest will be poor. In a similar way, it is important to observe seasons of rest as an artist. It can be hard if a quiet season is forced upon you. All manner of factors can halt productivity, from health and family concerns to changing fashions, let alone unexpected things such as a global pandemic. Neither excessive busyness nor enforced quiet are fertile grounds for an artist to sow. Yet these fallow times can also be seasons of restoration, to allow the nutrients of rest, reflection, research and experimentation to nourish our creative soil.

At times art can be a rest in itself from other work and pressures. I find this in my own studio, which has become a refuge of solitude on many occasions. Especially for those of us with more introverted tendencies, art can provide a moment of quiet

or space for meditation; an intense focus on making something where stressful thoughts can be left to the side even if only for a moment.

When you read about art history in school textbooks you might be forgiven for thinking the changing seasons in art occurred in a conveniently linear succession. The great movements of art flow effortlessly from year to year as one chapter ends in time for another to begin. If we look at the history of art in the Western tradition over the last two centuries, it is clear that art history is a messy and complex business. Movements coexist and contradict one another, often being informed by events outside the art world such as the great World Wars and epidemics such as the plague and Spanish flu. These global events both interrupted the flow of art history and became catalysts for change.

With that in mind, an analogy with the seasons is problematic at best. In reality, life as an artist is more like that of art history, being less compartmentalized and having seasons collide. A time for weeping happens on the same day as a time for dancing. Days to plant seed can also feel like days we're being uprooted. A time to rest might also be a time to work. Indeed, most artists never really stop working. When we go on holiday it's to somewhere we see as a research opportunity. When we relax with a book it's something relating to our practice. Even social occasions like parties and gallery visits become networking opportunities and research trips.

EBB AND FLOW

The seasons of art are a messy business and rarely do they flow neatly from one to another. As I write, it is spring, yet today it is both bitterly cold and the garden is flooded with sunshine. Like the great Romantic poet Wordsworth, who wandered lonely as a cloud, we may experience multiple seasons in one day. Perhaps it's better to think of the artist's life more as a great river that crashes and bubbles around us. It picks us up and sweeps us along. At times carrying us forward, at times pulling us back. At times we sink, at times we swim. We ebb and flow, we rest and work, we flap, flounder and float all at the same time.

Recently, we have experienced a new global interruption of epic proportions. A great coursing river that will affect the arts for many years to come. Some things will change for ever and others will remain the same, yet little of its course can be predicted or affected by individual artists. In a way, we have to go with it. At times we will sink and at times swim. We will ebb and flow, but this is normal in the course of art history and likewise in the life of an artist. As theologian Reinhold Niebuhr (1892–1971) once prayed, '[G]rant me the serenity to accept the things I cannot change, courage to change the things I can, and wisdom to know the difference.'

COME AND HAVE BREAKFAST

As a lockdown project, I've been reading *The Lord of the Rings* again. I read it as a teenager and suppose that, like many in the early days of the pandemic, I felt the need to return to old comforts. I had forgotten how much time the hobbits spend at the beginning of the book sitting around and having breakfast. In fact, they tend to enjoy a second breakfast on most occasions. Then there's all that faffing around in the Shire. It takes a full six chapters before they actually leave, and I must admit that was about as far as I got with my reading.

Before the hobbits begin their great adventure and life together, they must meander around to find where the journey begins. Even the story seems to meander in those opening chapters as Tolkien finds his territory and the plot proper begins. Many of us, too, may need to have a second breakfast, a time to replenish the creative soil and prepare for the journey ahead. It brings to mind the unexpected words of Jesus in John's Gospel as his disciples come in from a hard night's fishing and he has prepared a meal for them on the shore. On other occasions he has said, 'I am the way, the truth and the life.' Elsewhere again he said, 'Go and make disciples of all nations,' but here, on the banks of the Sea of Galilee, as his friends drag their weary feet up the beach, he invites them to 'come and have breakfast'.

Before the disciples began their epic adventure, Jesus invited them to sit, drink and eat with him. Like the hobbits, they were

encouraged to have breakfast with their King. Many of us need this divine appointment: to drink coffee and eat bagels, to come and have breakfast with Jesus. Remember, it wasn't just the meal that offered them rest. The disciples were restored because they ate with Jesus. Like the disciples, weary from the night's work, many of us simply need to sit in the presence of Jesus and find our rest there.

Work less. Rest more. This is not to advocate laziness, but rather to recognize that we work at our best when we find our restoration in Christ. As I begin my studio day, I'm in the habit of praying. Before the emails come crashing in, before the colours are mixed and the work begins, I light a candle at my desk and ask for the Lord's help. This simple devotion begins the day and has become a regular meditation. As it happens, I have made a painting every day of the matches used to light the candle. They have become a diary of prayer or a counting of the days. Indeed, the painting itself has become a meditative act. This simple discipline of daily devotion reminds me of our need for Christ throughout every rhythm of an art practice.

Art is made in and out of season. It rests in the fallow of winter, blossoms in the spring and matures through the summer until the fruit is ripe in the autumn. The great river of art ebbs and flows, at times bending to our will and at other times carrying us forward. Yet through it all we are invited to rest in Jesus, our Rock, Refuge and Redeemer.

WHY ART MATTERS

Through the course of this book I have argued that art matters. Art matters because people matter. Art speaks for the voiceless and reminds us of the times we live through. Art matters because *matter* matters. The stuff of the universe was made by God and reminds us that all things are connected to him in Christ. Art matters because it helps us celebrate with greater joy and lament with deeper sorrow. Art matter because God's Word tells us it matters. Throughout the Bible we see how God's people sing, make music, dance, draw and build. Art begins in the opening chapters of Genesis and keeps going through to the splendour of the new creation.

Art matters because it cleans windows in the new creation, wiping away the dust of the fall that we might catch a glimpse of the good things to come. Art matters because it gives us courage to build with great ambition, to embody ideas with hopeful imagination and to envision the new creation in bricks and mortar, pixels and paint. Art matters because beauty matters. Art reminds us that we are invited into an experience of God that is more beautiful than anything we could possibly imagine, and this is the glory of God.

Art matters because it abides with us through the storm. It reminds us of the things that have always mattered. It lifts our eyes to eternity and reminds us of the value of everyday things.

Art matters because it asks the difficult questions no-one else has the courage to ask. Art matters because the Spirit of God courses through it. Listen carefully and you just might hear his voice. Art matters because it changes the way we think, live, move and have our being. Art matters because it has always mattered, from the beginning of human culture, through seasons of plenty and seasons of want, through war, famine and disease; wherever there has been human life there has always been great art.

Finally, art matters because *you* matter. There is no human in time who does not matter to God. The art you make, whether displayed in public museums for centuries to come or lost to the sands of time, whether performed on the national stage or made round your kitchen table with your children, matters. It matters because you made it and you matter. You are made in the image of the Creator God. In him all things were created and through him all things are redeemed.

… And this is why art matters.

NOTES

1 **Eyes for art**
1 John F. Kennedy (1917–63), thirty-fifth president of the USA (1961–
 3); speech dated 26 October 1963.
2 Genesis 2:9, NIV.
3 A. L. Kennedy, from her documentary *Designing Dundee* for BBC
 Radio 4, first broadcast 27 August 2018.
4 Grayson Perry, from his 2013 Reith Lecture entitled 'Playing to the
 Gallery – Democracy Has Bad Taste', first broadcast by BBC Radio 4.

2 **Art of the matter**
1 James Elkins, *What Painting Is* (Routledge, 1999), p. 2.
2 Alain de Botton, *Religion for Atheists* (Penguin, 2012), p. 215.
3 E. H. Gombrich, *The Story of Art*, Pocket edition (Phaidon Press,
 2006), p. 39.
4 Colossians 1:16.
5 Colossians 1:17.

3 **Punching holes in the darkness**
1 C. S. Lewis, *A Grief Observed* (Faber and Faber, 1961), p. 3.
2 Joe Lazauskas, speaking about his book, *The Storytelling Edge* (Wiley,
 2018), on the podcast, The Marketing Book Podcast, on 16 March
 2018.
3 Aleks Krotoski, cited at <www.planetshifter.com/index.
 php?q=node/1926>
4 Betty Spackman, 'Introduction' in *A Profound Weakness: Christians
 and Kitsch* (Piquant Editions, 2005).

4 **Van Gogh's Bible**
1 Bono, 'Introduction' in *The Book of Psalms*, Pocket Canon edition
 (Canongate Books, 2011).
2 Genesis 2:23.
3 Colossians 1:20.
4 Isaiah 65 and Revelation 19.

5 **Make good**
1 Every effort was made to find the source of this quotation; it was seen

in a publication by the Tony Shafrazi Gallery that included prints and text by Andy Warhol, which went out of print in 1997.

2 At the time of publication, Turnau is working on a book titled *Planting Oases: Christian Imagination in a Post-Christian World*, where he develops this idea of artist as zookeeper to the imagination.

3 Fujimura develops this point in his book *Culture Care* (IVP, 2017).

4 Hart describes the role of the artist as an apprentice in the workshop of God in his book *Making Good* (Baylor University Press, 2014).

5 Joshua 5:3.

6 Judges 3:16.

7 Judges 8:27.

8 Judges 14:10; 2 Samuel 3:20.

9 1 Kings 7.

10 See, for example, Exodus 1:14; Psalm 104:23; 1 Chronicles 27:26; Leviticus 23:7; Lamentations 1:3.

11 Genesis 1:12.

12 Ruth 2:18.

13 Genesis 4:1.

14 Colossians 1:16.

15 Ephesians 2:10.

16 Genesis 1:28.

7 Why beauty matters

1 I am indebted to the writing of two friends, Roberta Green Ahmanson and Ben Quash. It is inevitable that some of their ideas will find their way into this chapter and I would like to give them credit.

2 Isaiah 52:7, NASB.

3 Song of Solomon 1:10, (N)KJV.

4 Isaiah 52:7.

5 Umberto Eco, *On Beauty* (Secker & Warburg, 2004), p. 85.

6 From her speech 'Why Beauty Matters', delivered at our Morphē Arts conference 'Why Art Matters', June 2018.

7 From his lecture 'Why Beauty Matters' at the Morphē Arts conference 'Why Art Matters', June 2018.

8 Isaiah 52:7.

9 Romans 10:15.

9 Standing stones

1 Mark Wallinger, *Art for All?* (Peer, 2000), p. 133.

10 Come and have breakfast

1 Mike Breen, *Multiplying Missional Leaders* (3DM International, 2014).